THE HERE AND NOW

The Photography of Sam Jones

THE HERE AND NOW

The Photography of Sam Jones

HarperEntertainment

An Imprint of HarperCollins*Publishers*

For Zoie, James, and Avery

HarperCollins books may be purchased for educational, business, or sales promotional use. For information please write: Special Markets Department, HarperCollins Publishers, 10 East 53rd Street, New York, NY 10022.

FIRST EDITION

Library of Congress Cataloging-in-Publication Data has been applied for.

ISBN: 978-0-06-134812-9
ISBN-10: 0-06-134812-0

07 08 09 10 11 ID/TOPPAN 10 9 8 7 6 5 4 3 2 1

FOREWORD

I've never really met Sam, but I hear he's a wonderful photographer.

The pictures you see of me in this book were taken by James Wong Howe. My agent lost a bet to his agent, and to pay it off, I'm writing this foreword.

If I really had known Sam, I would say this: He's the best to work with. He has a great eye, and more than that, a great sense of fun.

Most actors do much better in front of "film in motion." Twenty-four frames tend to give us the ability to project personality. One frame scares the hell out of us. So only a few photographers can get famous people to put their guard down. Sam's one of them.

. . . or so I'm told. I don't know why you would want to have this book of pictures on your coffee table when there's such good TV out there, but if the cable goes out, I guess . . . there's a lot of good in this book:

Jack Nicholson dancing

Anna Nicole showing off baked goods

A couple of girls in bikinis (I think Mark Wahlberg is in that shot)

Mel Gibson yelling at the camera (thought those pictures were all bought up)

Male, full frontal nudity . . . wow!

Thumbing through this book, I realize that this is better than cable.

Sam Jones. Talented beyond his years . . . and I'll tell him that when I meet him.

—George Clooney

PREFACE

I've never been on a Sam Jones shoot. In this, I am at a distinct disadvantage to my fellow introducer, George Clooney, whom Sam has shot twice for my magazine, *Esquire*. Clooney has actually seen Sam work. (This may not be the only advantage Clooney has over me.) I've published dozens and dozens of Sam's photographs and commissioned a great many of the shoots that yielded photographs included in this book. And still I have never seen him work. In part, that's because I believe in letting people surprise me with the brilliance of their work and because I think one of the great barriers to creativity is having some authority figure imposing him- or herself on the creative process. In the case of photography—especially celebrity photography—it merely complicates what is already an intensely complicated process—the collaboration of photographer and famous person.

The first time I worked with Sam was a cover featuring David Duchovny. When I heard that he planned to put Duchovny in a straitjacket, wrap him in chains, and suspend him upside down in a tank of water and THEN shoot the first photo, I was both nervous and skeptical that anyone—let alone a man who had the hottest show on television at the time—would do such a thing. And when I heard that Sam's idea for the cover was to fill Duchovny's face with acupuncture needles, I despaired for the shoot's prospects. It says a great deal about Sam's technical ability that Duchovny survived the day and even more about his charm that Duchovny continued to think highly of both Sam and the magazine.

It was his next shoot for *Esquire* that yielded one of the most important photos Sam has taken, especially for *Esquire*. I was in my second year as editor in chief and, to be honest,

the magazine had been wandering. The original men's magazine in America (founded 1933) was seeking a definition of what it should be as we all approached the end of the twentieth century.

I can't say that I expressed any of this to Sam, but the cover photo Sam took for the October 1999 issue was as clear a definition of what American men in general—and *Esquire* readers in particular—should strive to be. That photo begins this book. It showed Clooney walking against a tide of blandly suited everymen and not only expressed the magazine's longtime tag line (Man at His Best) but *updated* it. It was a visual statement: This is a man among men, and that became the cover line: "A Man Among Men, The George Clooney Story."

When we got that first Clooney shoot from Sam, he sent in a plethora of shots and setups and one more thing. Sam had helpfully mocked up a cover using the crowd photo, cropped just so and with the *Esquire* logo above it, an act of design that mightily, um, *delighted* my brand-new design director.

Since then, he's shot many of the most famous people in the world for us and for many other publications. He's also become a film director. But Sam still approaches his assign-

ments in two ways that set him apart from other photographers.

The first is a breadth of imagination (and the ability to get his subjects to collaborate) that is all too rare in modern celebrity photography, which too often tends toward little more than beauty shots. Even in Sam's more conventional portraiture, a restless intelligence shines through.

And, more important, is his unique ability in this age of insane celebrity idolatry to humanize these people who often seem entirely estranged from the world the rest of us live in. Look at the photos of Jack Nicholson goofing around in his driveway or of Matt Damon acting like a little kid. Yes, these are photographs; this is artifice, but the effect is to make Nicholson or Damon seem like one of us, in part because Sam finds the humanity they share with all of us and also because he convinced them to play along.

This book is about celebrity, yes, but it's also about one artist's ability to use fame to create something uniquely delightful.

—David Granger
Editor in Chief
ESQUIRE
March 20, 2007

THE HERE AND NOW

The Photographs of Sam Jones

INTRODUCTION

When I was growing up I never thought about photography, or much of anything else that didn't involve my three major pursuits: skateboarding, playing guitar, and trying to figure out how to get through school without studying. I was either going to be in a band like my heroes, the Clash, or become a professional skateboarder.

After two years of college, I finally settled on a major of communication arts, which seemed ambiguous enough. It turned out that one of the required courses was photography. I borrowed a camera from a friend and started photographing all my skateboarding buddies on the streets and in the empty pools of Fullerton. Luckily, some of my friends were pretty good skateboarders, including Neil Blender, a big-time pro. He was also a great artist who encouraged my attempts with the camera and spent time helping me set up shots and taking me to skate contests where I built up quite

a portfolio of the best skaters in the world. I bought a wide-angle lens on his recommendation, and tried to visually re-create the feeling I had when I skated, getting as close to the action as I could.

I suffered through a few photo classes at college, mainly for free darkroom use. The pictures I shot for class assignments were usually done at the last minute or not at all. I remember dreading having to turn in a color or contrast study when I really just wanted to make skateboarding photos. My usual routine consisted of driving to a skate spot, skating until I was exhausted, then pulling out my camera to make pictures until it got dark—and then remembering that I hadn't shot some assignment involving shooting the same subject at five different times of the day. Boring!

My last photography class turned out to be my saving grace, and the reason I am a photographer today. The class was called Advanced

Photojournalism, and it was taught by Mark Boster, a born teacher who was also a great photographer. He worked for the *Los Angeles Times* and taught the class at night. This was my first glimpse into a working photographer's life, and I found it fascinating. Mark started the class by giving us the same assignment that he'd worked on for the *Times* the week before—a photo story on fishermen. Mark tacked our finished assignments on the wall and made both encouraging and critical comments, never making us feel like the amateurs we were. Mark brought his own *Times* fishermen shots to the next class. They were beautiful, insightful, and so beyond any of the students' work that we were all in awe. I made a decision right then and there that I would learn how to use a camera like Mark. I began to study photography in earnest, becoming enamored with the work of Henri Cartier-Bresson and André Kertész. I was amazed at their ability to transform ordinary life into a kinetic moment of artistic expression without leaving as much as a footprint on the scene. I also loved the portraits of Richard Avedon, Irving Penn, and Annie Leibovitz. How did they get their subjects to emote like that? Where did they come up with their ideas?

I took thousands of pictures in college, but one particular assignment of Mark's resulted in the first photograph I really *made*. It was our final assignment and my last chance to impress the teacher who had become my mentor. The assignment was a photo-illustration depicting the fear of HIV/AIDS. This was at a time when the disease was just starting to register in the national media, and typical of Mark, the assignment was one he'd done for the *Times*. I racked my brain for days, experiencing my first bout of "photographer's block." The day before the assignment was due, inspiration struck. I found an old mattress, borrowed a ladder, and convinced my friend James to cover his body in talcum powder. We waited until dusk and then dragged the mattress to a parking lot behind a liquor store. I doused the edges of the mattress with gasoline, and talked James into lying on it. I lit it on fire, climbed the ladder, and photographed the very scared James as he curled into a fetal ball to avoid the flames that surrounded him. I got off about six frames before James jumped out of there, fanning his singed hair and denouncing our friendship. We tried to put the fire out, which proved difficult, and ended up getting help from the fire department and the police, who were summoned by the owner of the liquor store. I talked the police out of arresting me, set up my tripod, and made a portrait of all the firemen, police, myself, and James (still half naked and covered in talcum powder).

I pinned my work up the next day with the other students', displaying not only the disturbing image of a blurry, ghostlike man lying in a burning bed, but also the odd group of people standing in front of police and fire vehicles. The images stood out from the other students' pictures of needles, frightened people reading AIDS pamphlets, and people waiting in doctor's offices. Nothing resembled my take on the assignment, and I started feeling I had failed. Mark went around the room discussing

the merits of each image, staying away from my picture altogether. The class was nearly over, and I was sure I had really screwed up the assignment, when he said, "now, I want you to give your undivided attention to this image here." He pulled my burning bed photo off the wall and proceeded to say that I had made a picture he wished *he* had made, and that in all his time teaching he had never seen such an original or arresting photograph. I have never felt prouder than at that moment, and to this day I credit Mark Boster for helping me find my connection to photography.

After leaving college I got a job as a stringer for the Associated Press. As far as I could tell, the only difference between a stringer and a staff photographer was that stringers got paid a lot less for doing the same job and were unencumbered by perks like a company car, health insurance, and access to camera gear. But it was still the greatest and most wild time of my life, and it taught me more about photography than I could have ever learned working in a studio or as an assistant to a big-time photographer.

I got the AP job straight out of college thanks to an unfortunate moment at a college basketball tournament. I was photographing Cal State Fullerton's game against the University of Las Vegas. A man in the stands had a heart attack and while the game was temporarily stopped, UNLV coach Jerry Tarkanian (very famous at that time in college basketball) went to the fallen man, who turned out to be a close friend of his. I shot a few pictures of this tragic moment, and the AP tracked me down and asked to see my film. Being an inexperienced student,

I hadn't learned to label my rolls of unexposed film, so an exasperated AP photo editor had to wait while I developed ten rolls of film, which he sifted through to find the picture he was looking for. He looked at more than three hundred of my pictures while searching for the image in question—the poor old guy gasping for breath with Jerry at his side. I thought he was going to pull his hair out, but he finally found the picture and sent it over the wire. As I was leaving, he said, "You shoot basketball better than most of our staffers. Do you want a job?"

The next three years of my life were a blur as I photographed just about every newsworthy event in the Los Angeles area. A not-uncommon day started at 5:00 A.M. at the downtown courthouse as I waited for convicted white-collar criminal Charles Keating to emerge in handcuffs, getting one scowling shot, then ran to the AP bureau to develop the film. I'd then head to the Westside to photograph Harrison Ford in his hotel room (five minutes only!), drive back to AP to develop and print that picture, then race up Hill Street to Dodger Stadium to shoot that night's game, trying to make a picture in the first inning in order to make early edition deadlines. I'd sprint up the stadium stairs to develop, print, and transmit from AP's lab on the loge level of the ballpark, hunching over an enlarger, mixing chemicals, and scarfing down Dodger Dogs just steps away from the immortal Vin Scully as he called the game. Then I'd run back down to shoot the last few innings for the late editions (RIP afternoon newspapers . . .), which of course necessitated another

trip up to the lab to again develop, print, transmit, and finally clean the lab (now switching from hot dogs to beer) before finally driving home at 1:00 A.M. The joy came the next day in looking at the stack of international newspapers in the bureau to find my work. I owe a dept of gratitude to AP (and now Reuters) photographer Bob Galbraith, who not only took me under his wing and taught me how to be a working photojournalist, but who has always been there for me through the many changes in my career.

It was hard-news photography that ironically provided an opportunity for me to start the next phase of my career. It was 1991 and Los Angeles was reverberating from the recent Rodney King beating that would eventually lead to the Los Angeles riots. I'd photographed police chief Daryl Gates surrounded by reporters as he tried to answer for his department's role in the events. *Vanity Fair* did a major story on the event, and used my picture of Gates as a double-page spread in their issue that famously featured a naked and pregnant Demi Moore on the cover. Actor/director Tim Robbins saw my picture and asked me to come to Pittsburgh to be the photographer for *Bob Roberts*, his film about a corrupt politician who is hounded by reporters and a documentary crew as he ascends to the U.S. Senate. He explained that my picture of Gates exactly fit the style he wanted for the still photography of the film. I jumped at this chance to make portraits of actors and to learn more about lighting from his masterful director of photography, Jean Lépine.

My experience with *Bob Roberts* was the gateway to the kind of photography I do now. One of the biggest challenges facing a photographer in my field is getting jobs shooting celebrities and other high-profile subjects. In my case, I wound up on the *Bob Roberts* set with twenty or so actors, and I took advantage of it. Besides doing the unit photography (scene-by-scene documentation of the movie), I cajoled the actors into posing for portraits. After three months I'd photographed Tim Robbins, John Cusack, Gore Vidal, James Spader, Susan Sarandon, Peter Gallagher, Alan Rickman, and several others, walking away from the job with a true portfolio.

My first magazine assignment was shooting a parking space! *Entertainment Weekly* actually hired me to shoot a celebrity's parking space on one of the studio lots to run with a story about some feud between two actors. And of course I agonized over it as if it was the cover of *Rolling Stone*. How can I make this parking space picture unique? How will it stand out over other parking space photographs? I think I shot ten rolls of film on that job, even enlisting a studio security guard to walk through the frame to add some mystery!

Eventually I moved up from taking portraits of actors' parking spaces to taking actual portraits of actors, athletes, musicians, comedians, and other interesting folks. The results are collected in this book. In my best attempts I hope I have managed to capture some moments that do justice to the talented people who have allowed me to photograph them.

My years at the AP taught me the most

important thing about my job—you always have to come back with a picture, no matter the circumstances. I remember showing up for an assignment to photograph the very beautiful young actress Jessica Biel, only to find we'd lost the location due to some permitting snafu. My whole concept hinged on the location, and I was distraught. We were in a not-too-desirable part of town, and Jessica was asking me what we were going to do. We sat in my car to talk about it, and I climbed into the backseat to look at a map book, hoping a location would magically jump out at me. I looked up and Jessica was looking over her shoulder at me; immediately I knew I had my picture. This was another lightbulb moment for me: I realized that a mistake, an accident, or a misfortune could sometimes create a better picture than one I had meticulously planned.

I've never drawn inspiration from just one stylistic point of view. I find just as much to love in Annie Leibovitz's portraits as I do in Cartier-Bresson's street scenes. When I approach a shoot these influences all tug at each other. My desire is to create an amazing, arresting image that no one has ever seen before, but also to find a spontaneous moment that is simply captured, then gone. Over the years I've learned that I am only happy when trying to satisfy both aesthetics.

The image of Steve Martin strolling through a street covered in banana peels is an example of this somewhat schizophrenic approach. I needed an idea that fit Steve's uniqueness and also paid homage to his humor. I came up with the idea of Steve being a comedian that

was adept at avoiding the clichés of a career in comedy. But I didn't want to plot it out so precisely that I didn't leave room for Steve to add to it. I decided to create a giant, real environment—more like a movie set, really—and then see what Steve would do with it. We peeled 1,800 bananas (no digital bananas were used) and placed them on the street. When Steve saw the set, he became a character in the "movie," skipping, dancing, and making the idea more his own than I could have ever hoped. That enabled me to take more of a photojournalistic approach to shooting, finding angles and seeing the photo unfold in front of me rather than controlling the whole environment.

I have a rather romantic view of how celebrity portraiture "used to be." As much as I understand that publicists, stylists, and editors all have their place at a photo shoot, I often long for the simplicity of what I imagine were the good old days, when William Claxton hung out for days at a time with Steve McQueen, photographing, riding motorcycles, and taking road trips; or when Jim Marshall spent the day with Bob Dylan as Bob found time to roll an old tire down the street on his walk to the studio. It seems like there was more opportunity for photographers to develop relationships with actors and make pictures that were more intimate and personal. I think all of that changed with Annie Leibovitz's tremendous influence over the art of celebrity portraiture. Annie managed to turn her portraits into major events, with huge crews, big sets, and giant budgets. She pretty much created the art that so

many photographers, myself included, study and practice. And as phenomenal as her influence has been, one casualty has been the gradual erosion of the intimate moment—or at least the expectation of one.

One person who understands this idea is George Clooney, whom I've had the privilege to photograph several times at sessions that have been more fun and satisfying than just about any I can recall. I've gone so far as to send him books depicting photo shoots from *Life* and *Look* magazines to show him concepts I aspire to. Photographer John Hamilton in particular had an incredible knack for getting very close to people like Clint Eastwood, John Ford, Paul Newman, and Shirley MacLaine, and I proposed a Hamilton-inspired shoot to George the last time I photographed him. He was immediately receptive and agreed to keep away everyone on his end (publicists, groomers, stylists) if I would keep away the big crew on my end. In addition, he said I could come hang out for a few days—at his house, at the studio, etc.—a real old-fashioned behind-the-scenes shoot. The resulting pictures are some of my favorites, all made in natural light with a 35mm camera and no one around. It's refreshing to make pictures this way and I find they are just as satisfying as the ones that require fire permits, animal wranglers, traffic control, and an army of assistants.

In editing this book, I tried to select pictures that are most true to the subjects' personalities. When shooting, I am very aware of how uncomfortable it can be to be photographed; that doesn't change just because someone is famous. My effort to make the subject feel comfortable and relaxed starts with extensive research. I try to familiarize myself with their life and accomplishments, and to find something unique about them. This helps me to come up with ideas that fit my subjects, and to create an environment where they can relax and be themselves. After reading dozens of interviews with Renée Zellweger, I discovered in an obscure Canadian publication that she has a secret penchant for the compositions of Mr. John Cougar Mellencamp. I promptly went out and bought a "best of" CD. The very real laughing moment that appears in this book was the direct result of my cranking up the "little ditty about Jack and Diane."

I've also learned some lessons from subjects who decide *not* to participate in one of my ideas. Ultimately, if someone doesn't feel comfortable with a concept, it probably wasn't the right picture to take. But when the idea is right, and the subjects want to jump in and participate, it means I've found a way to connect with who they are; they can forget themselves for a while and we can make some truly unselfconscious pictures. I'm drawn to "caught moments" that are too imperfect to be created; I try to control a portrait up to a point and then let it take its own course.

I've always tried to create an environment that seems part of a bigger story, and then capture a small part of it. The idea behind the photograph of Matt Damon was to create a day that every guy would love to have in his memory: a mud football game, a small lake with a great dock to jump off, a homemade

raft to float around on, and maybe even a little fishing. I set up this "day" and brought Matt into it. Fortunately, he's not the kind of guy who'll say, "I don't want to get too muddy," but the kind who digs in all the way. Once the story was set up he dove right in. I was free to observe, capture, and be surprised by the moments that followed.

When I am lucky enough to have an actor of Matt's level willing to spend an entire day getting muddy, waterlogged, and stung by a bee, I love my job.

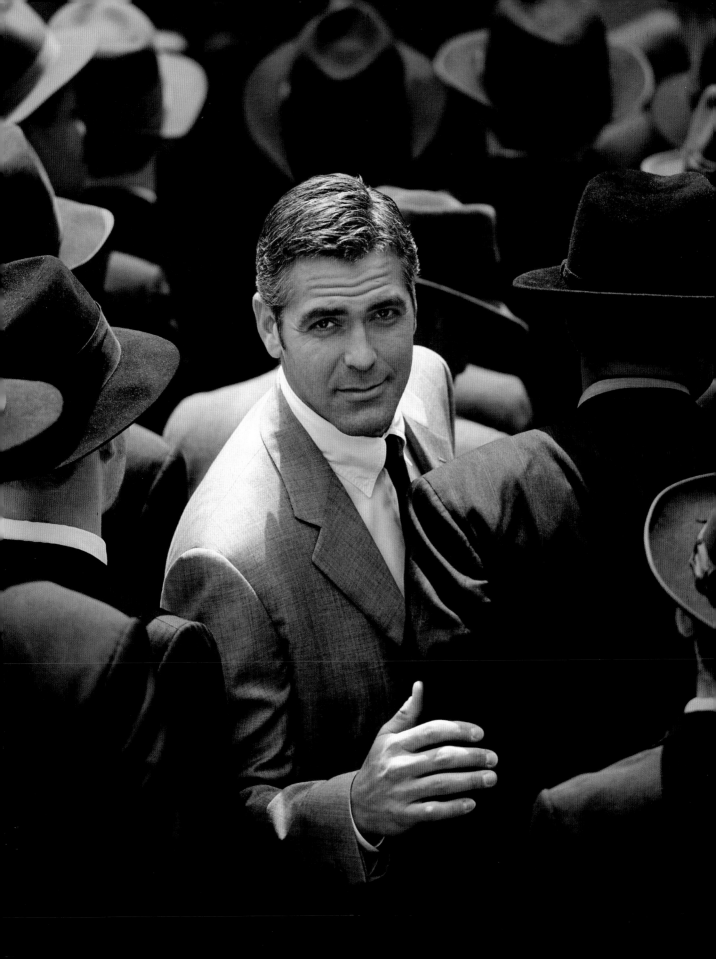

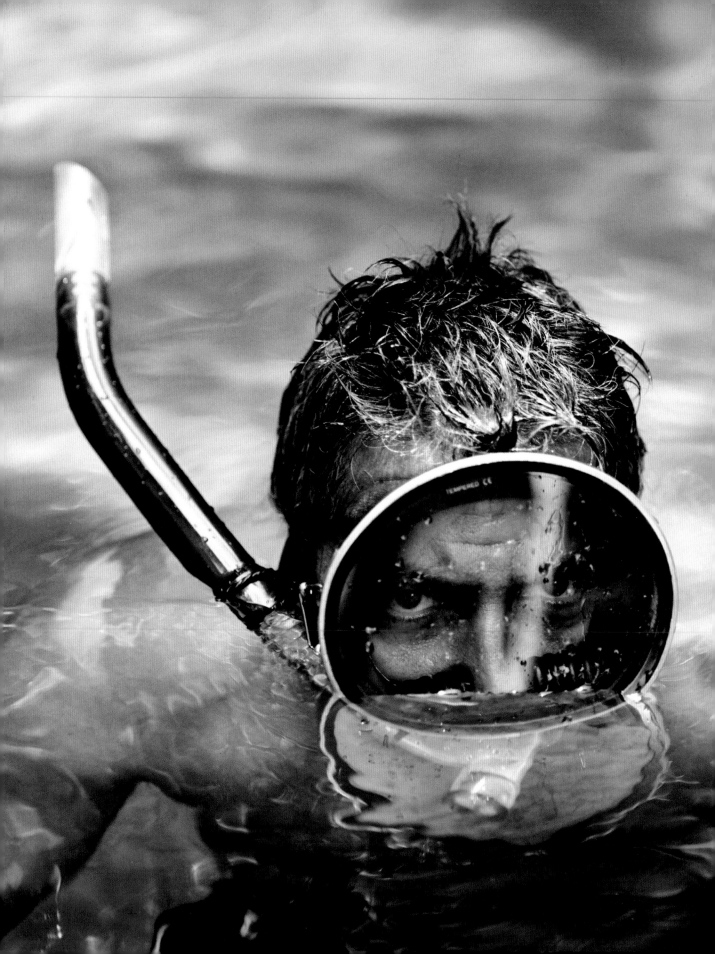

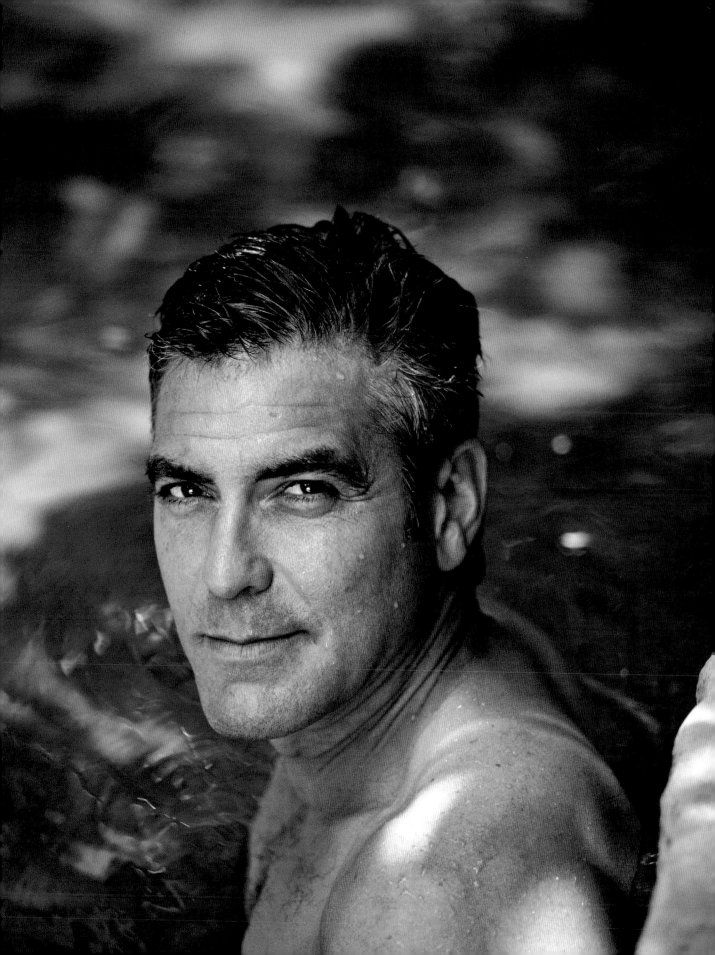

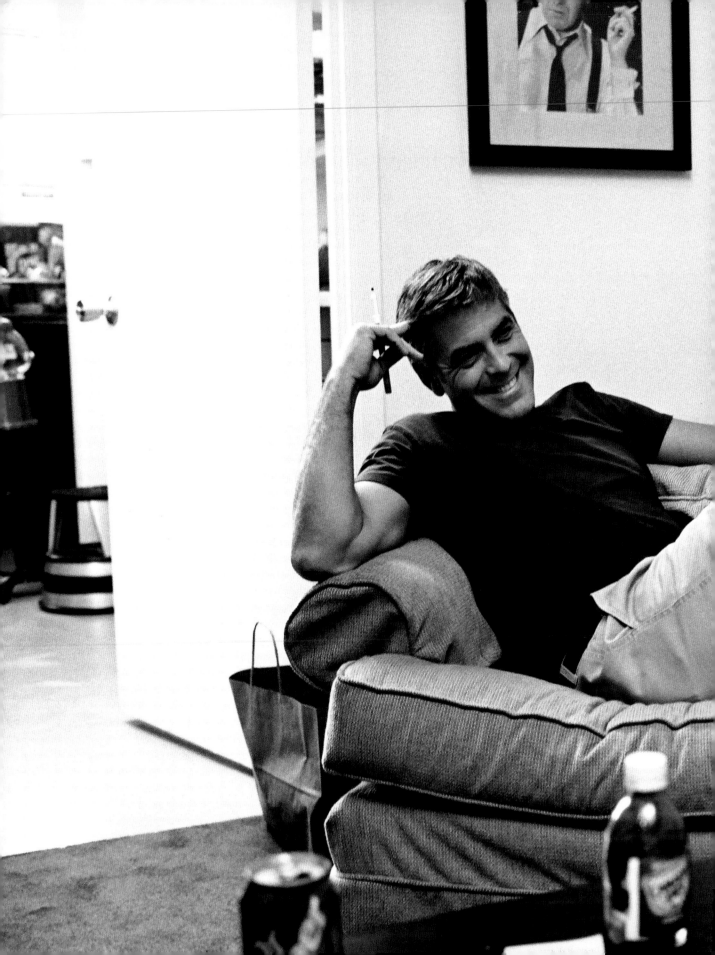

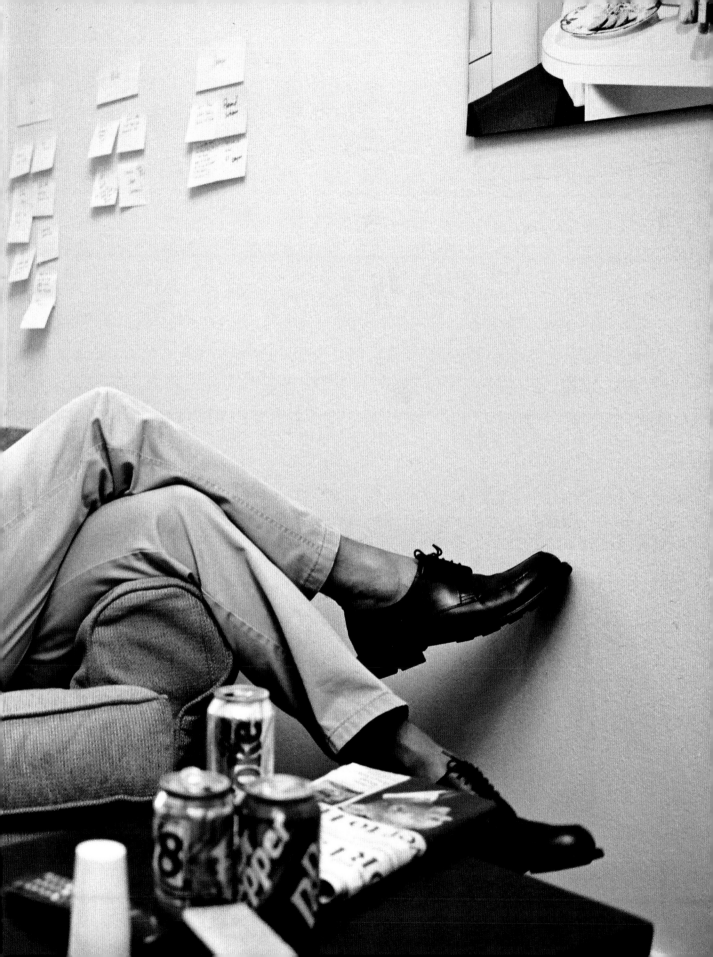

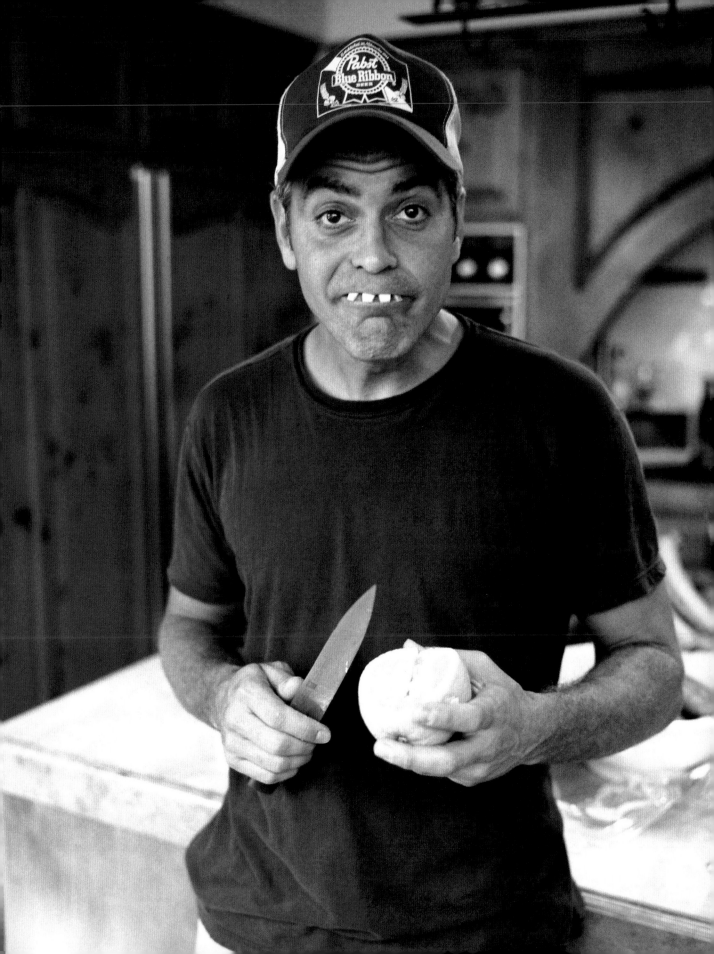

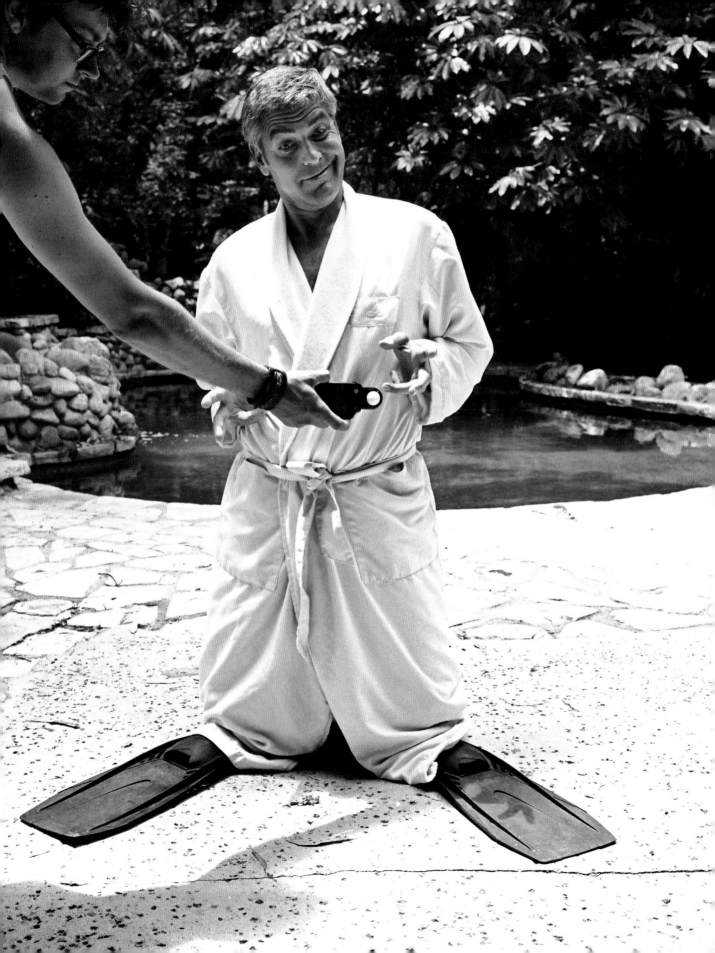

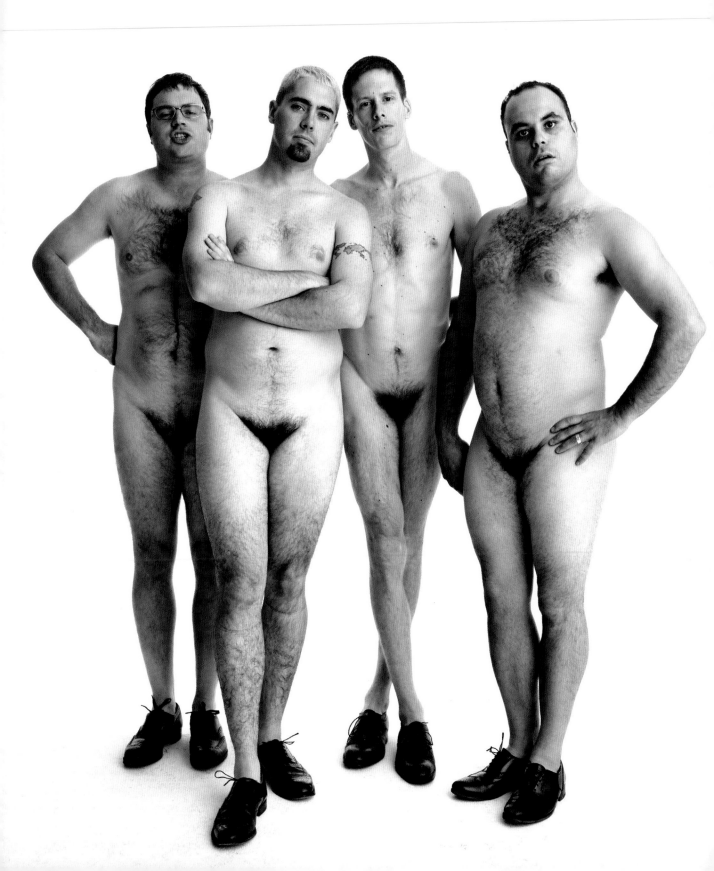

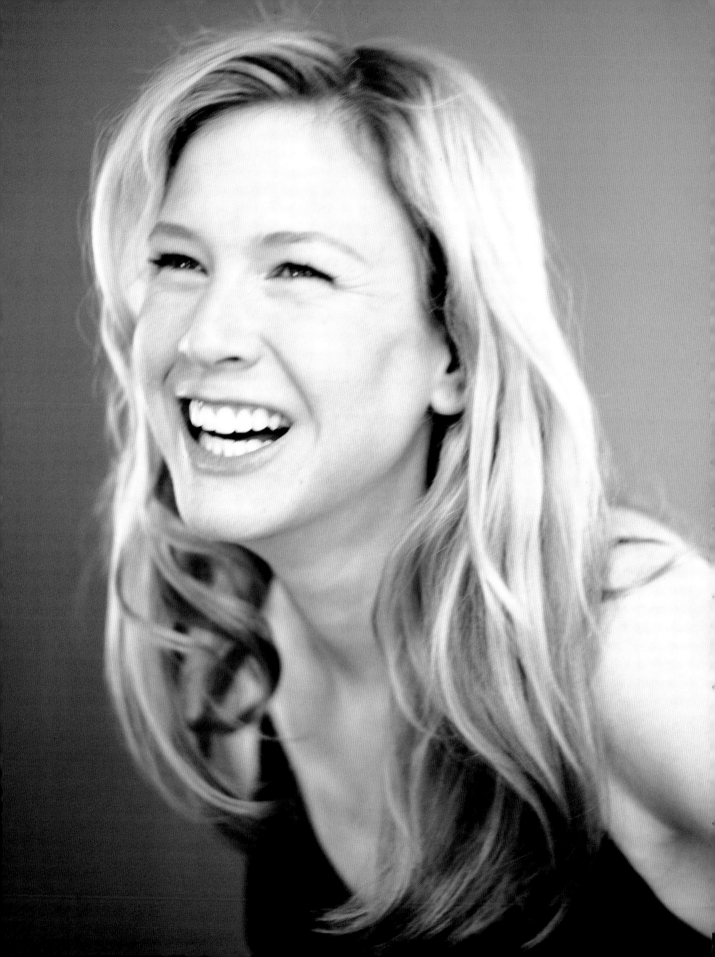

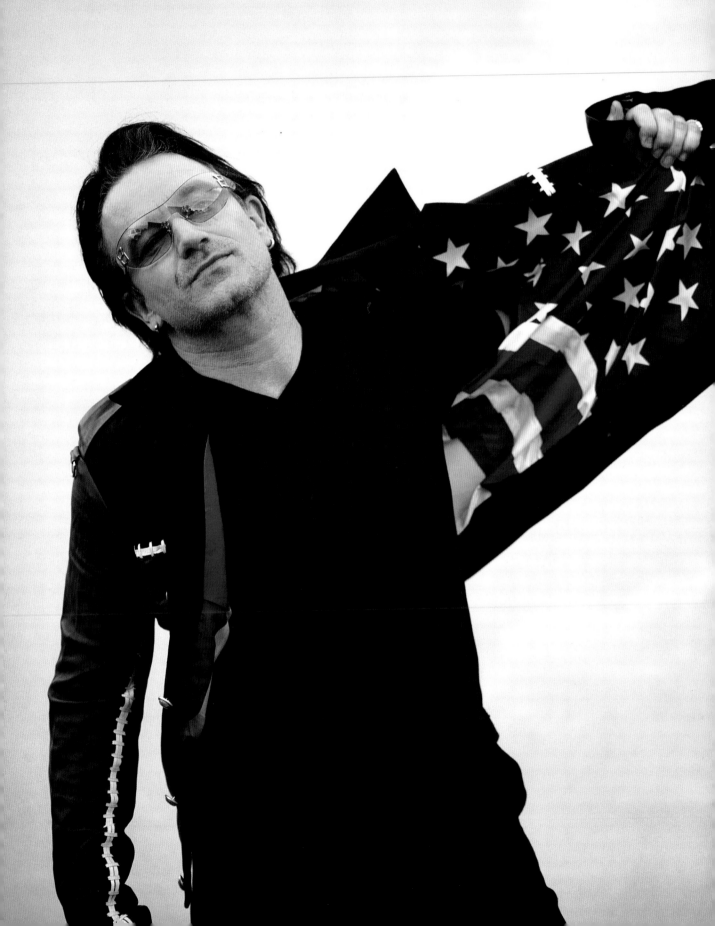

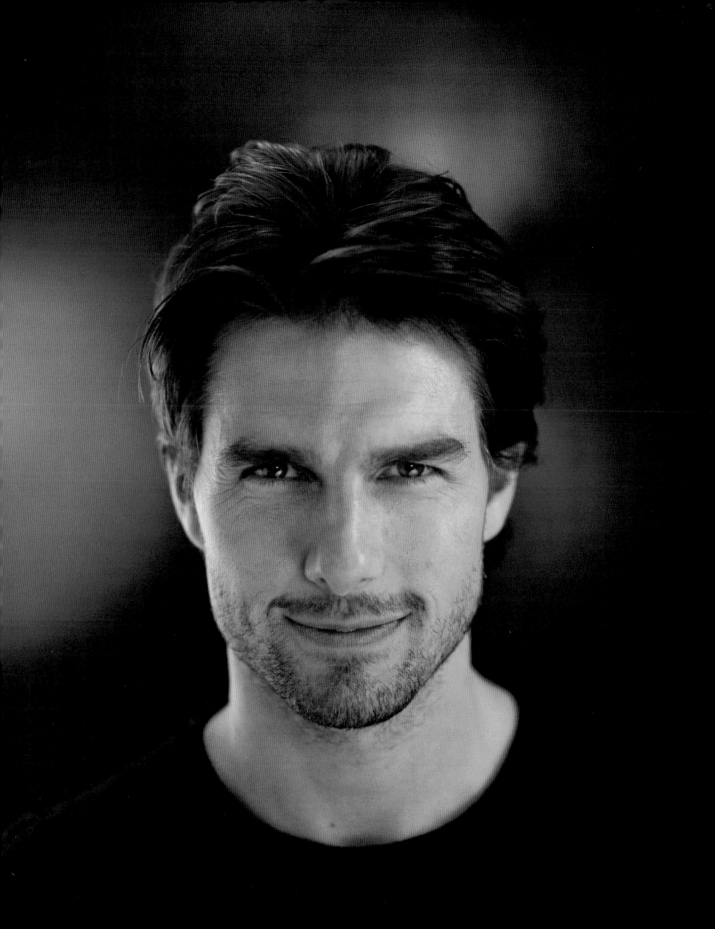

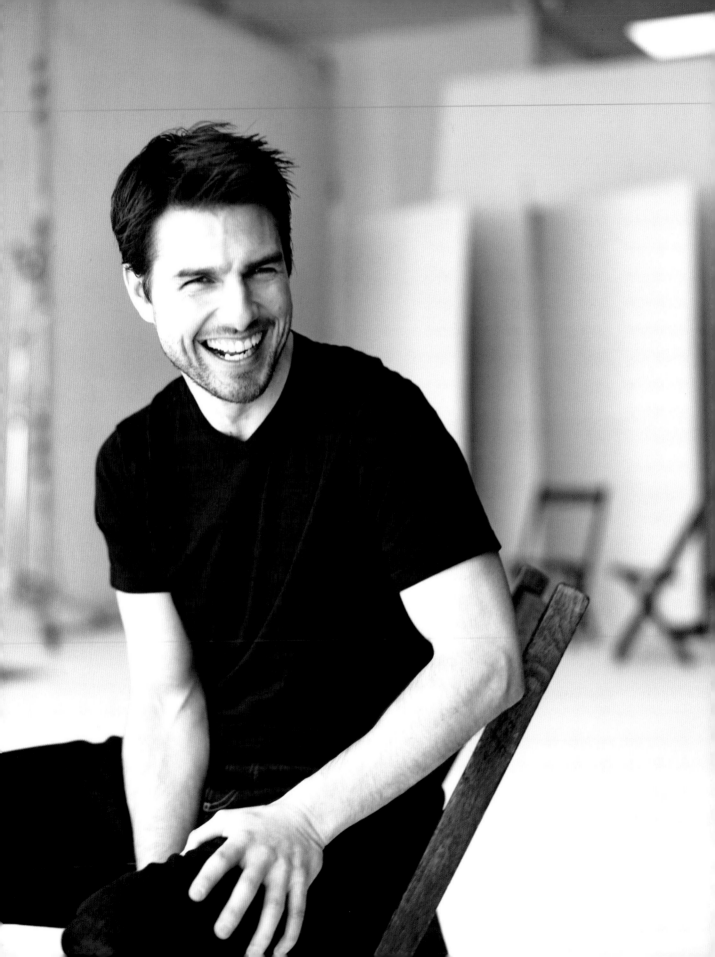

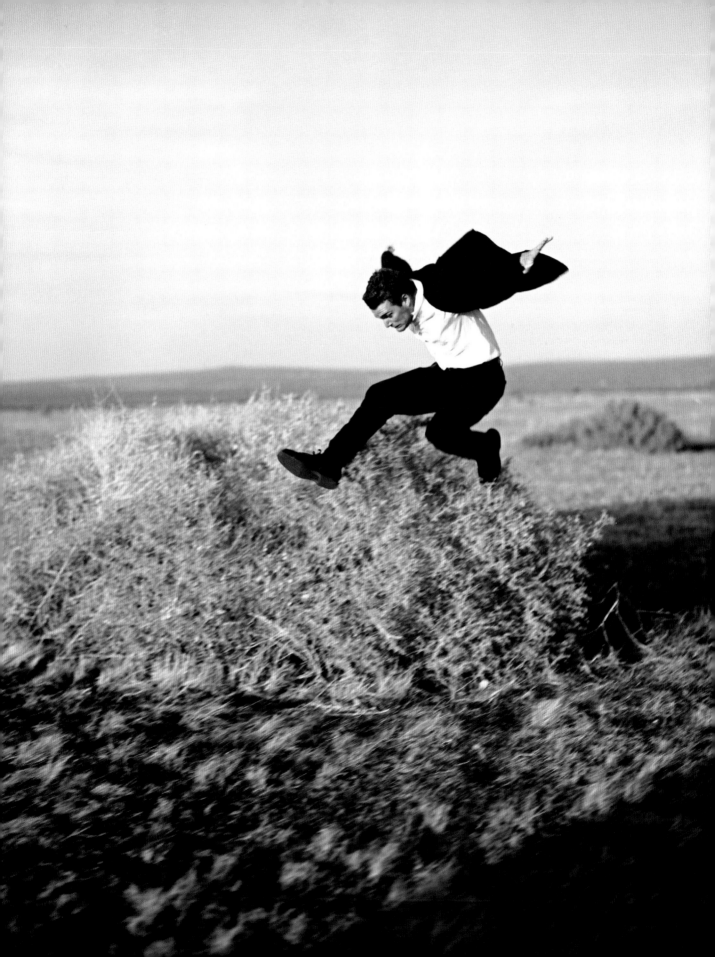

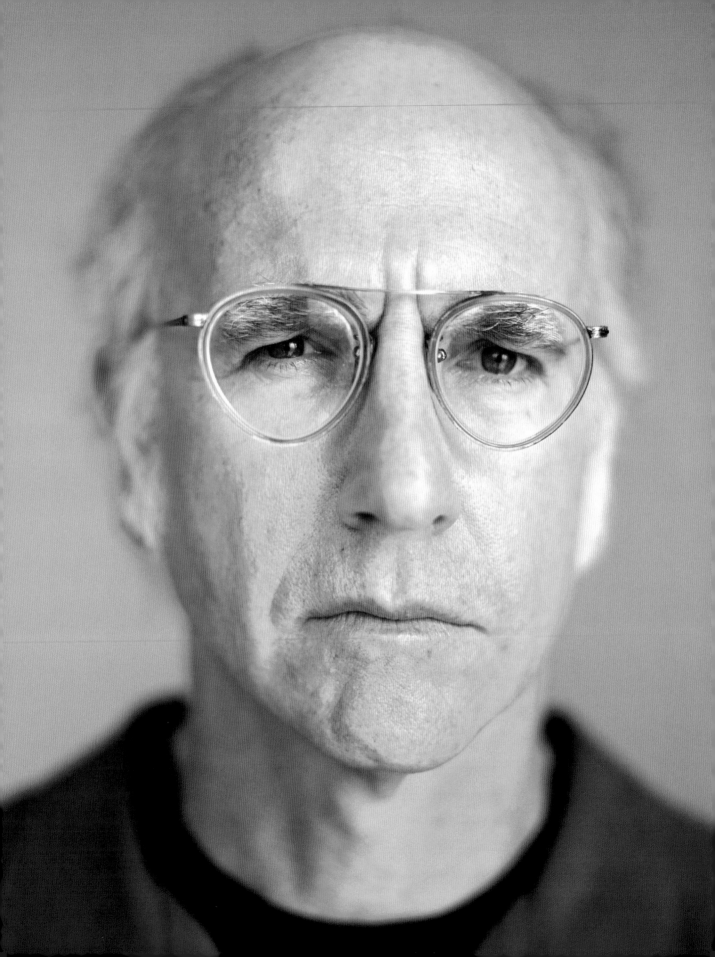

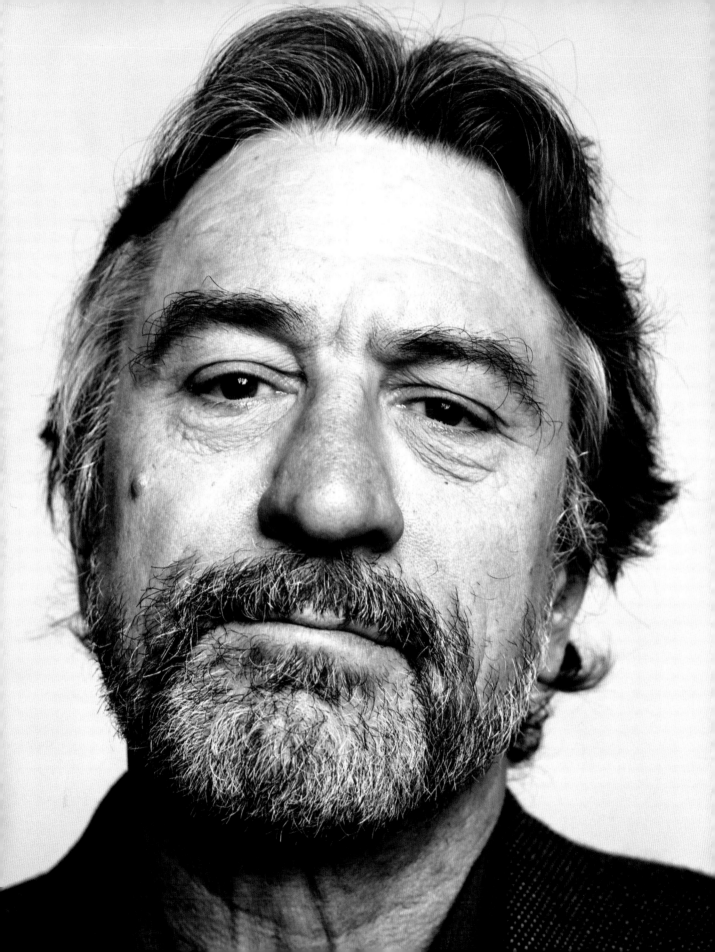

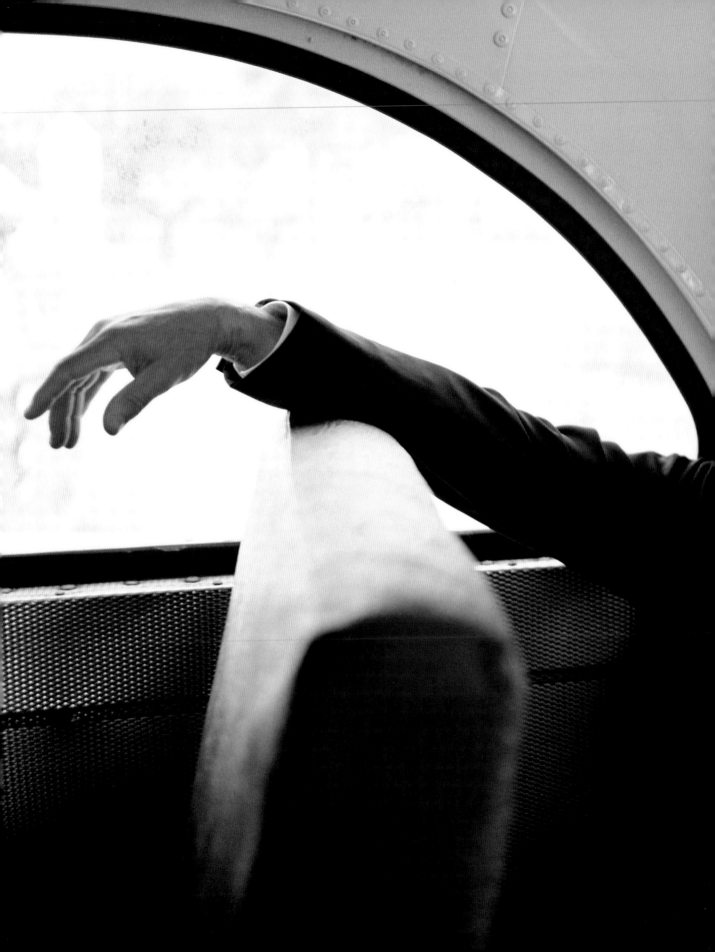

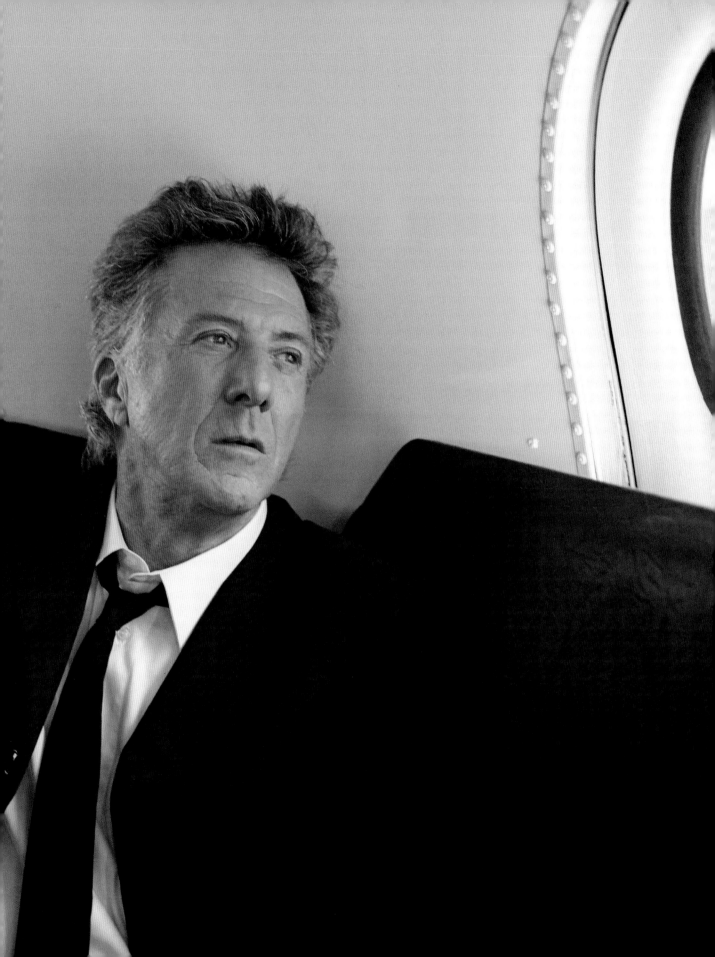

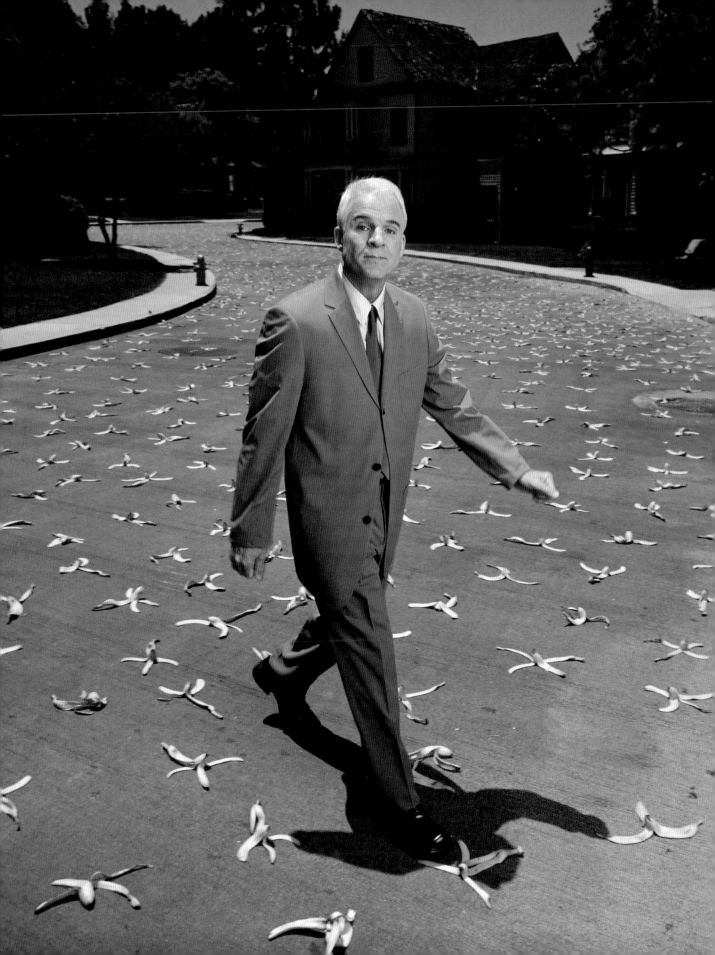

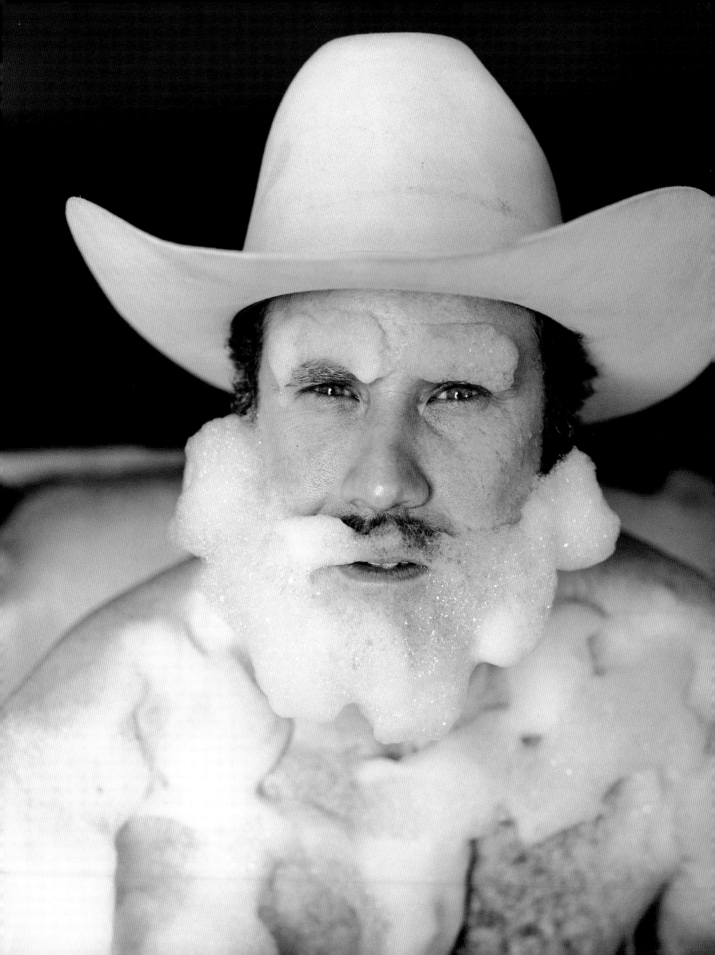

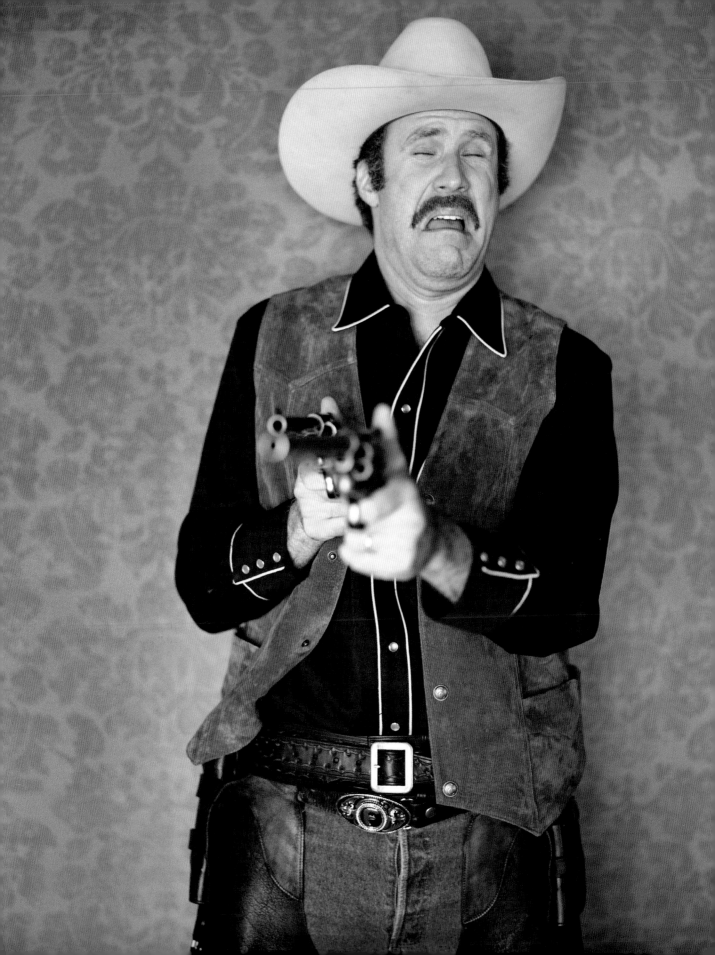

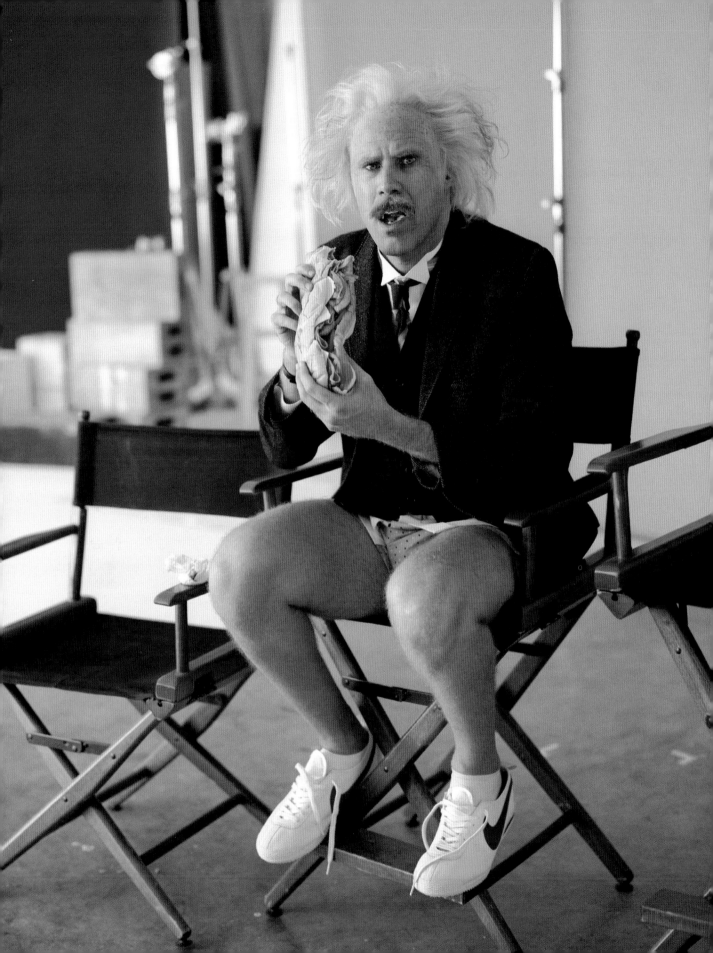

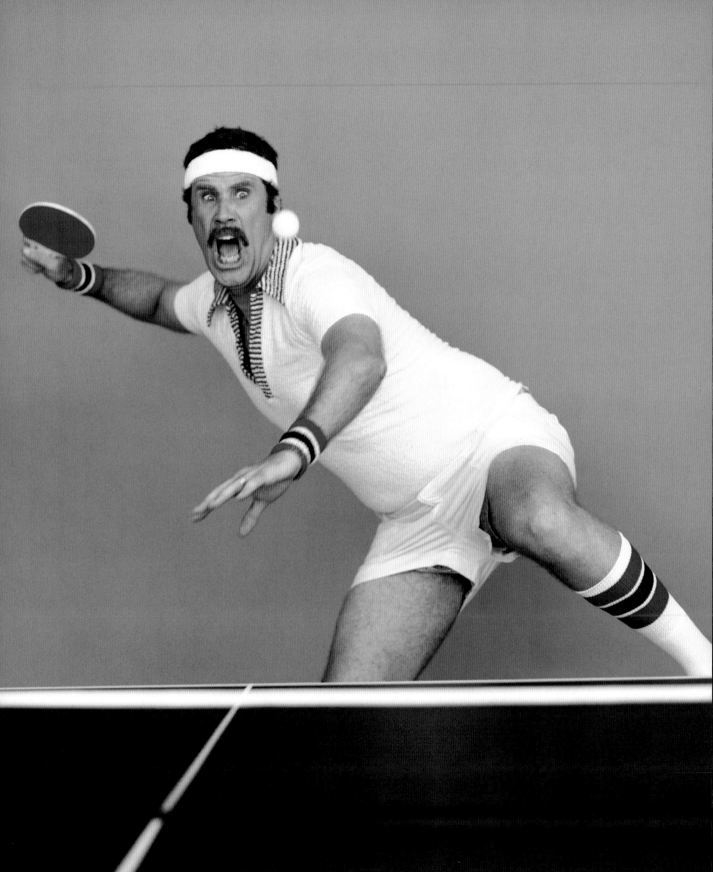

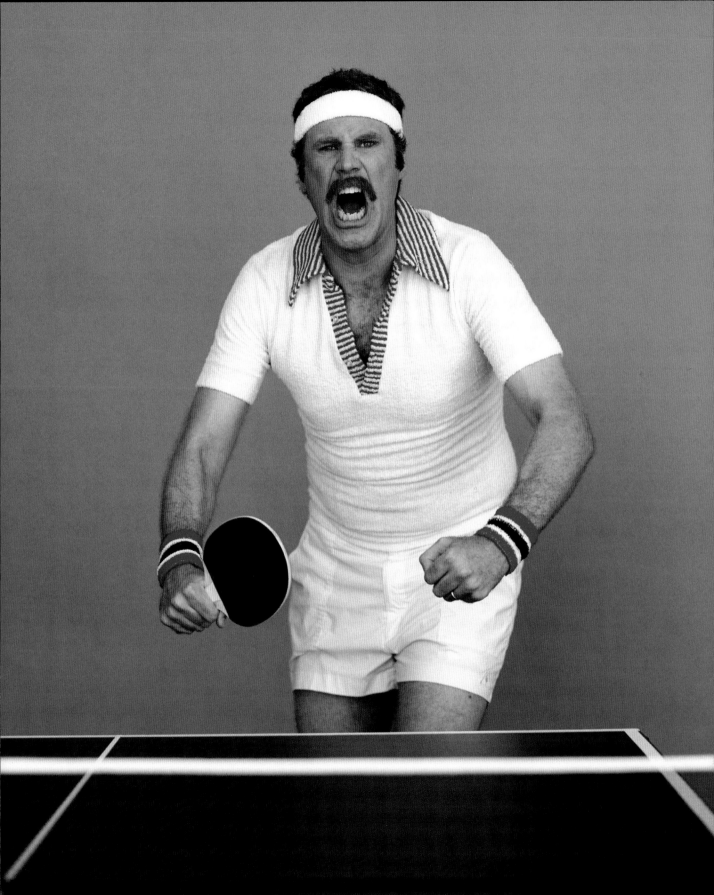

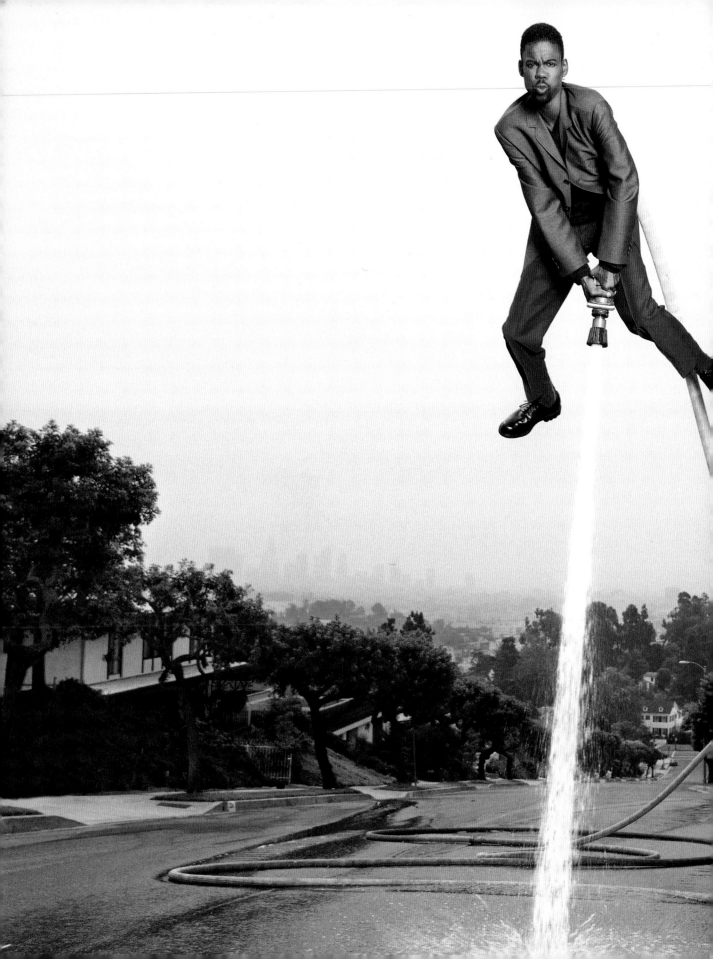

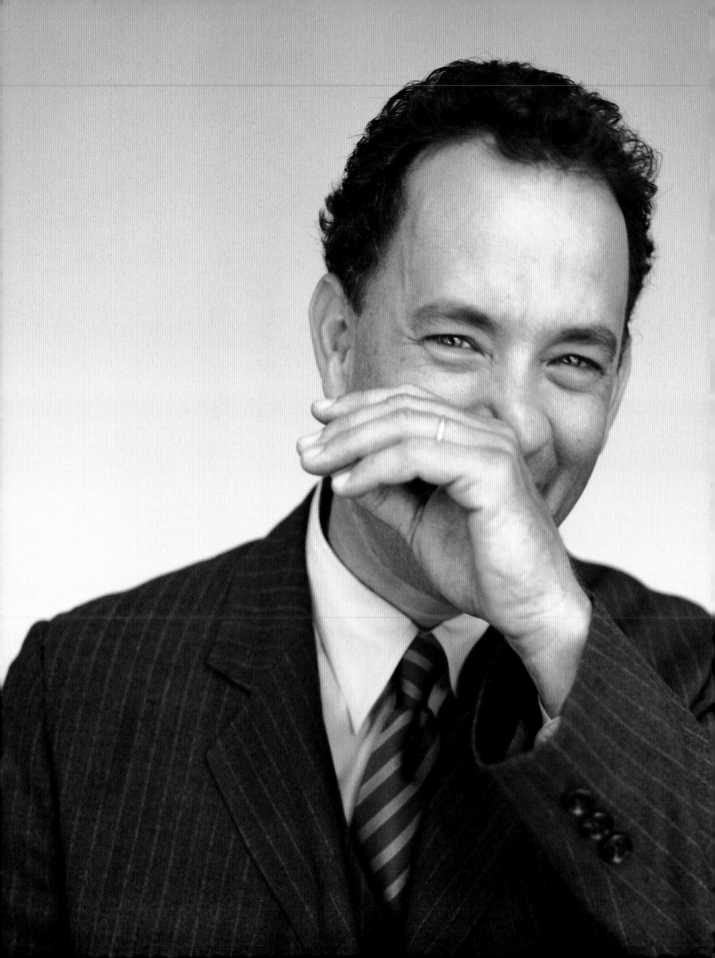

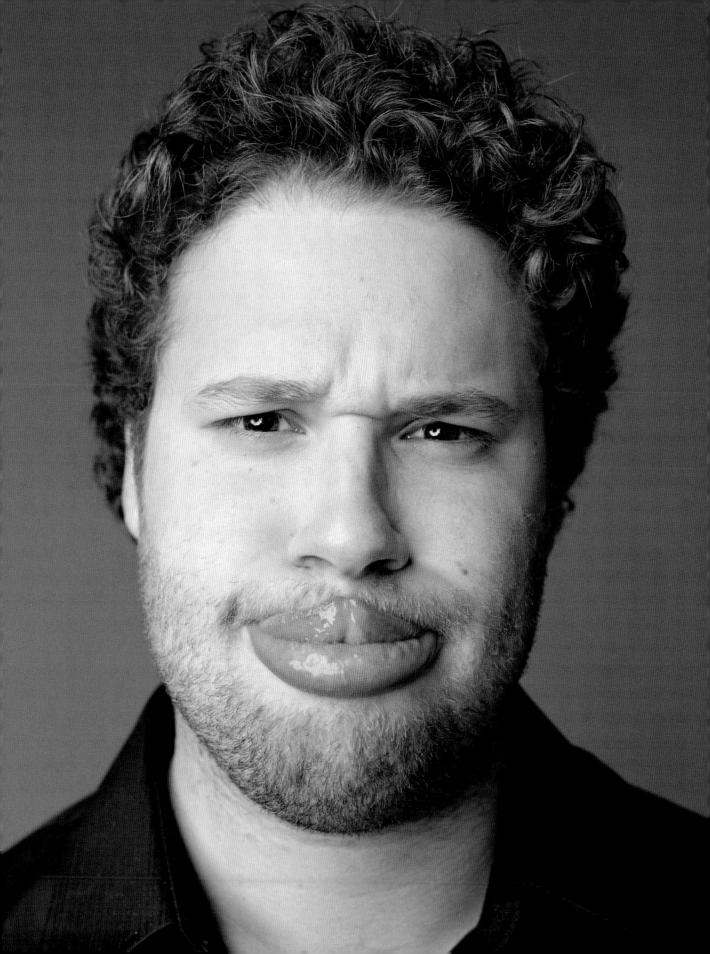

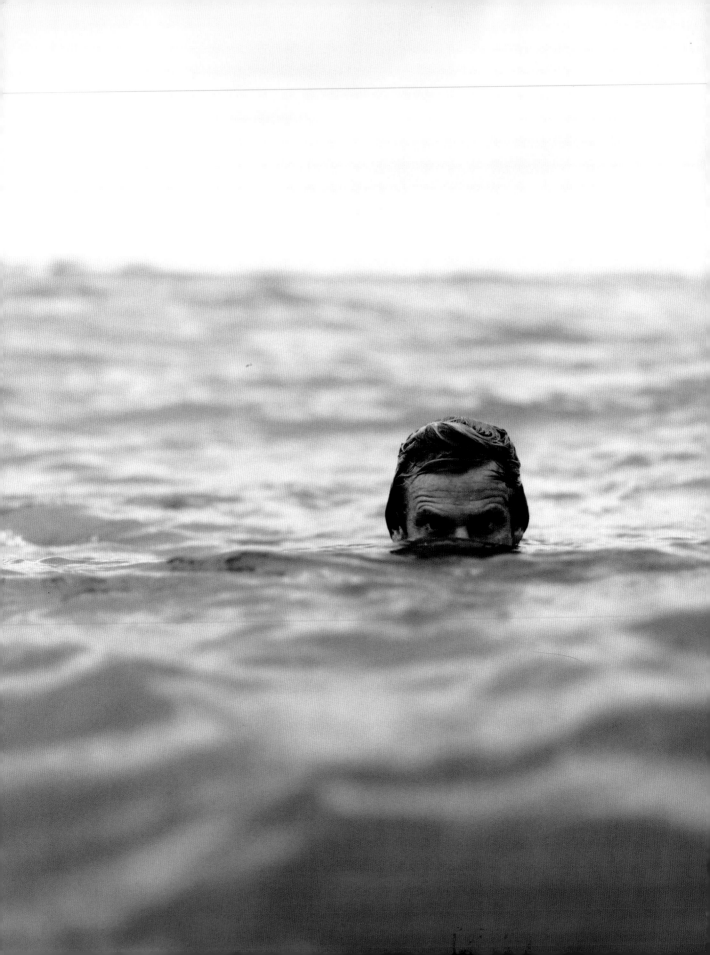

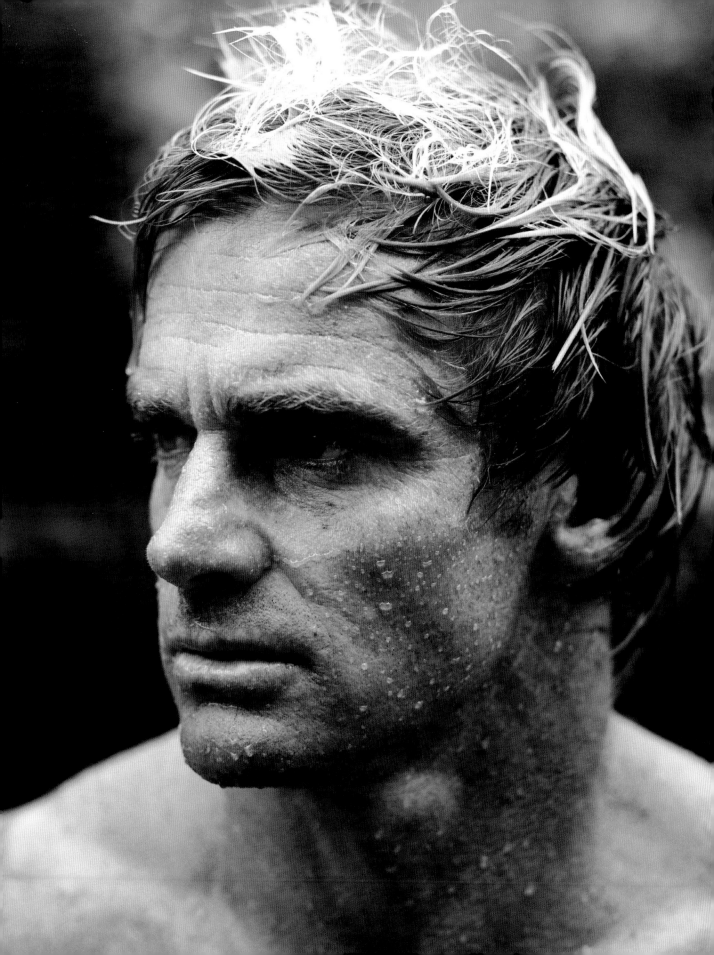

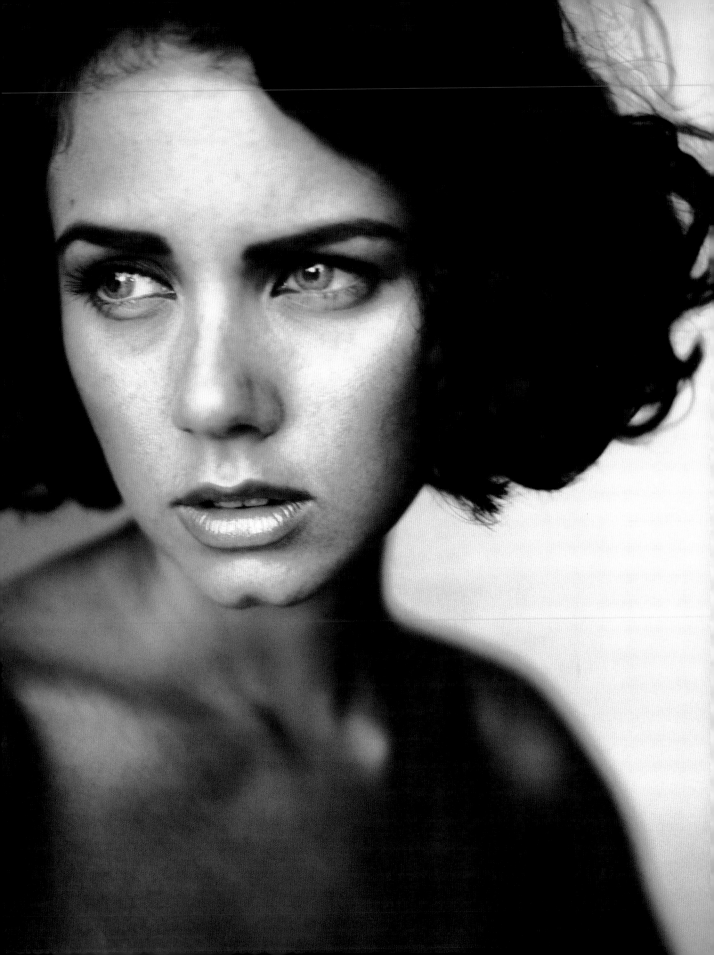

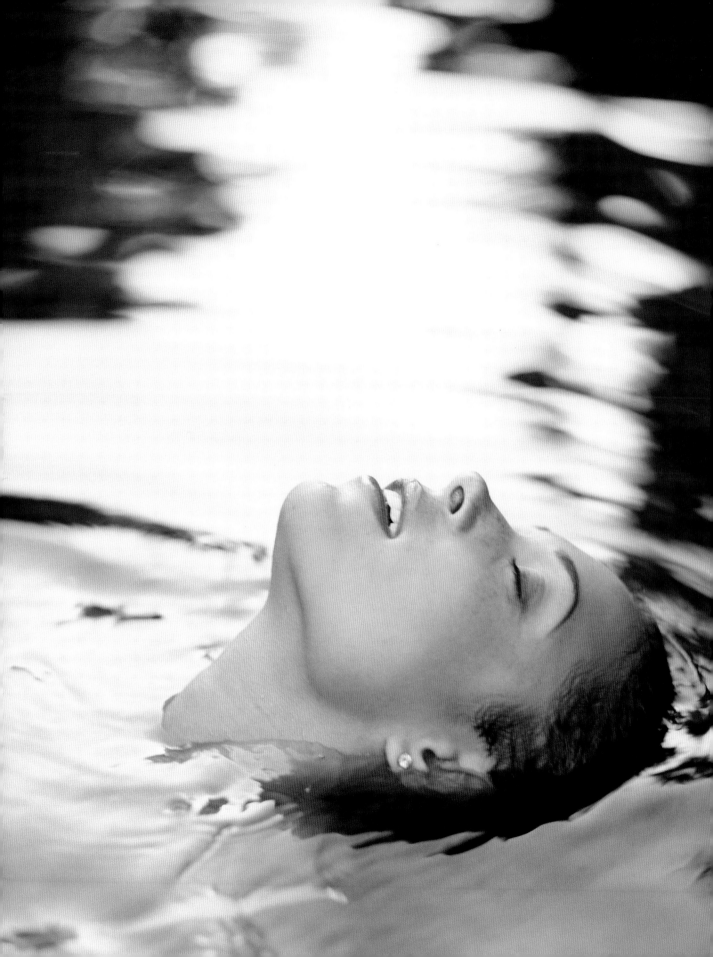

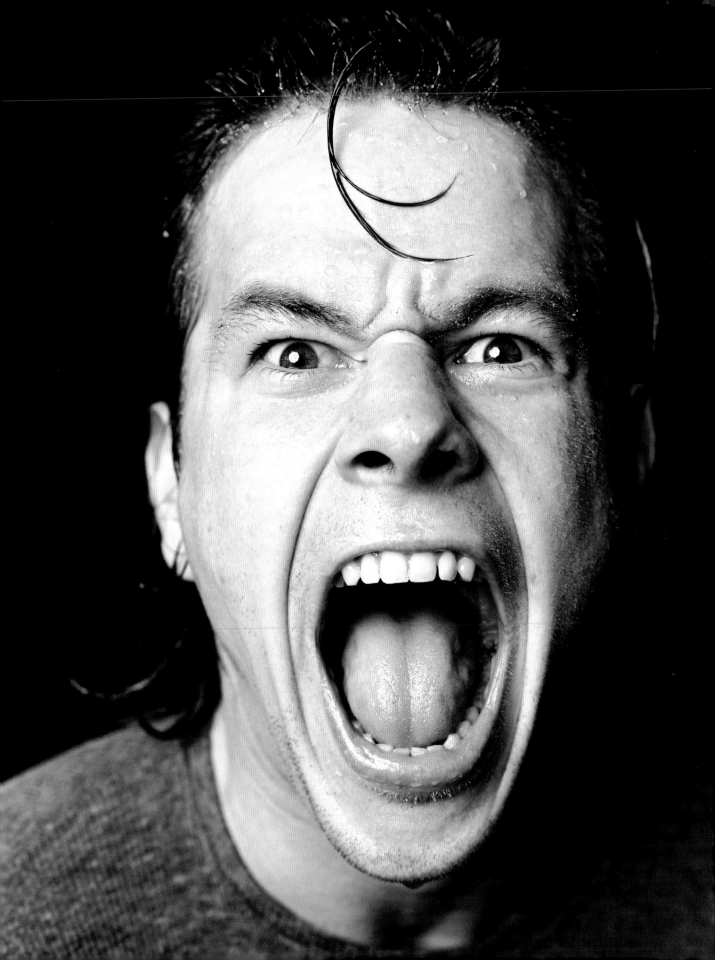

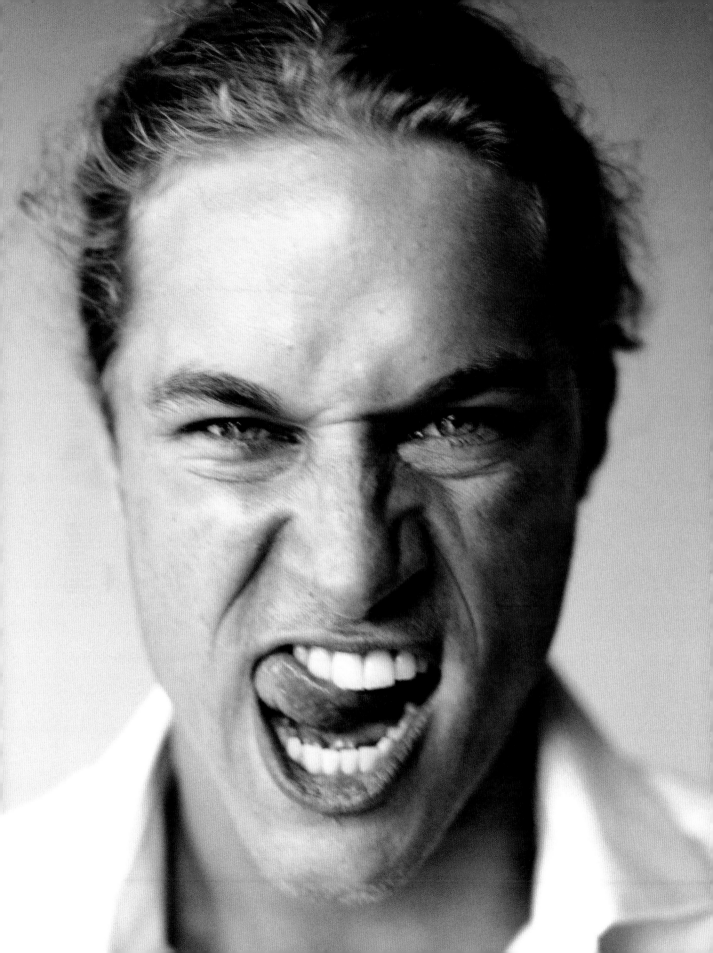

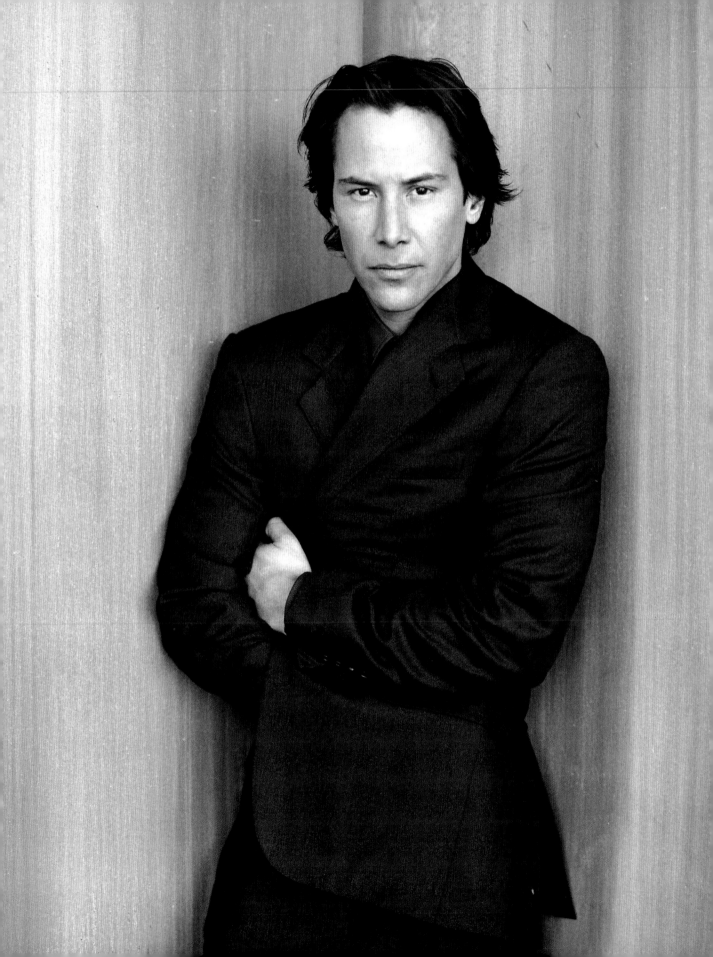

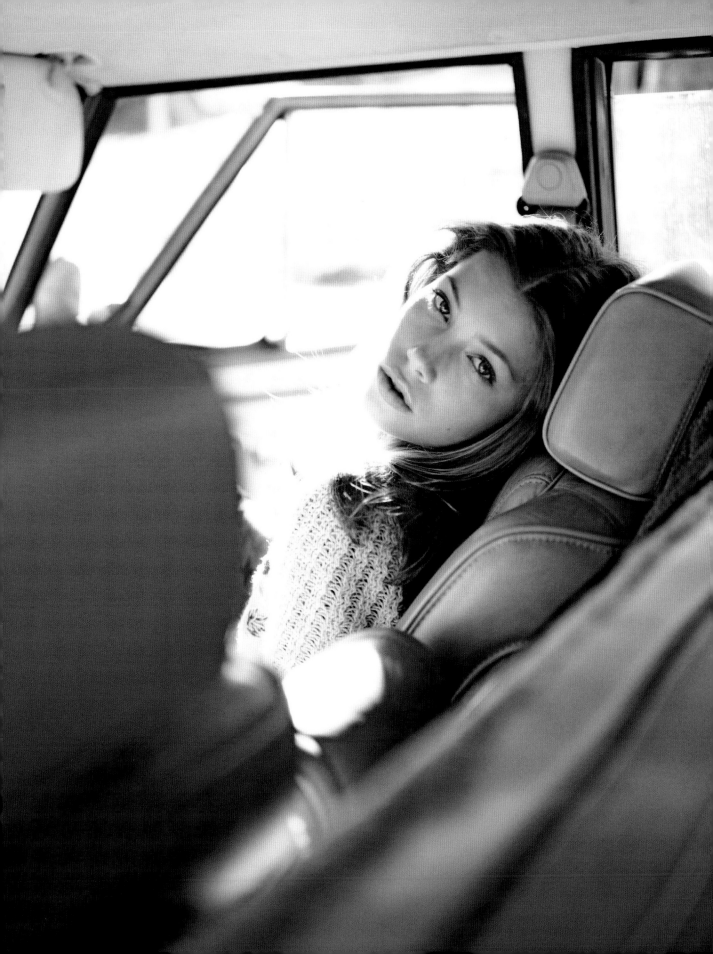

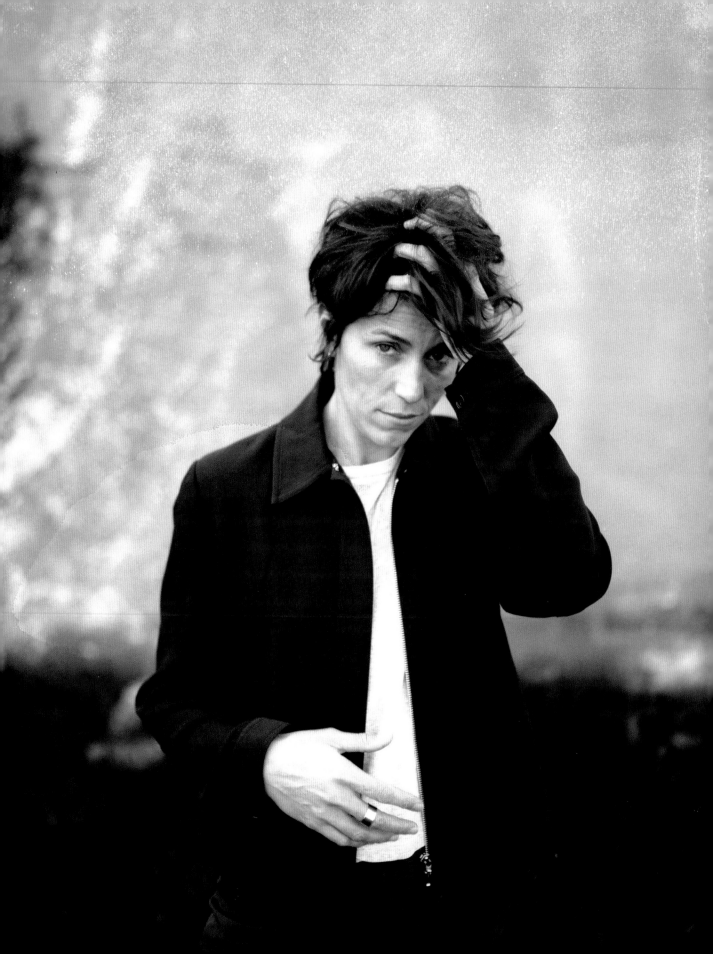

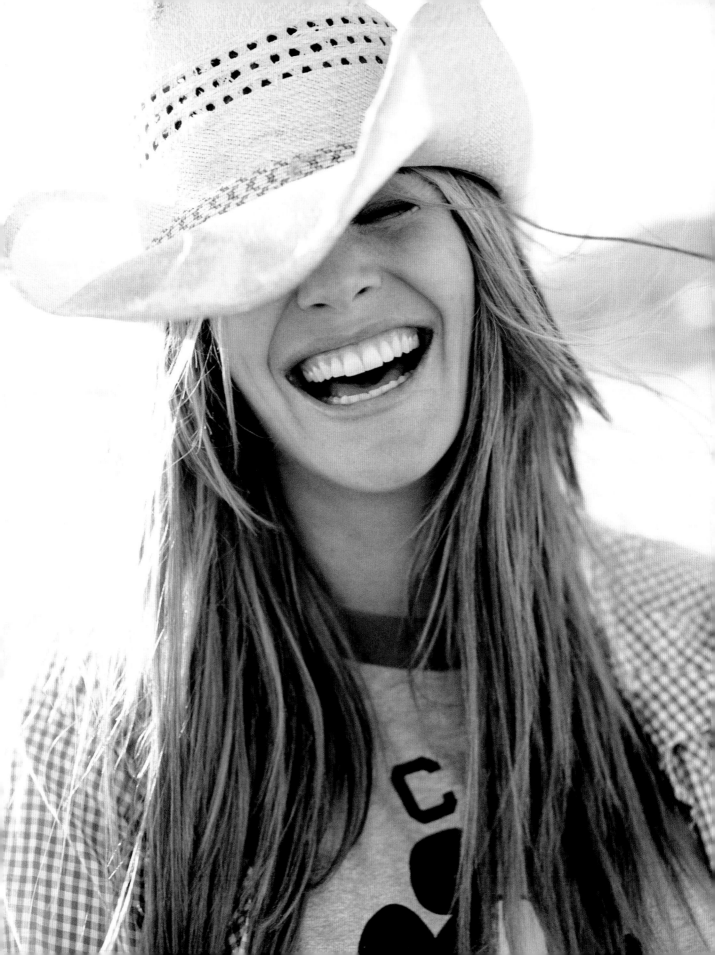

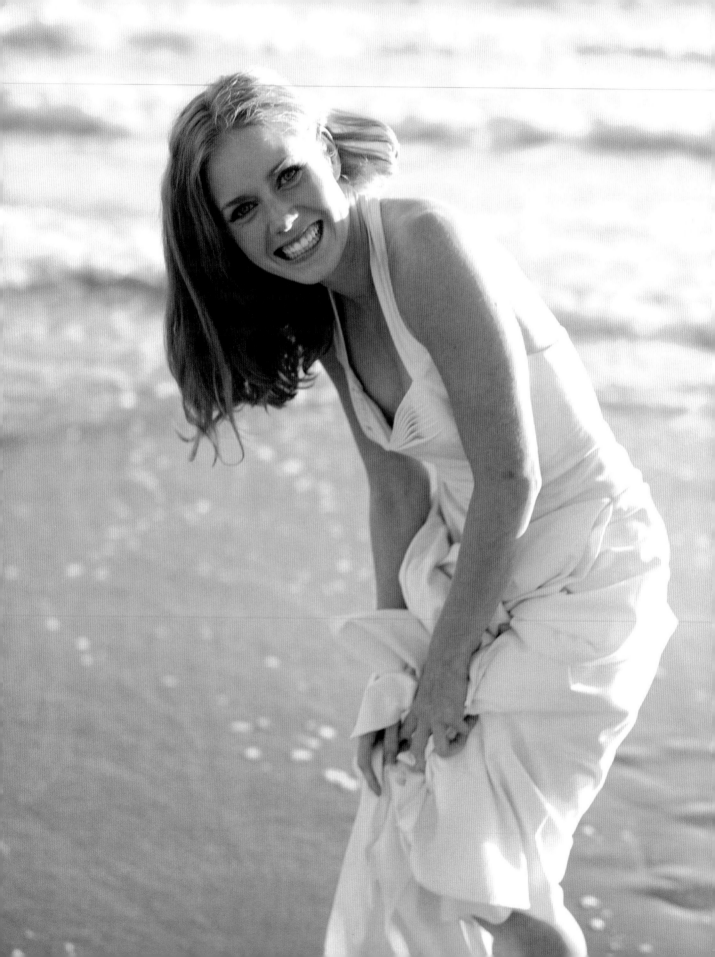

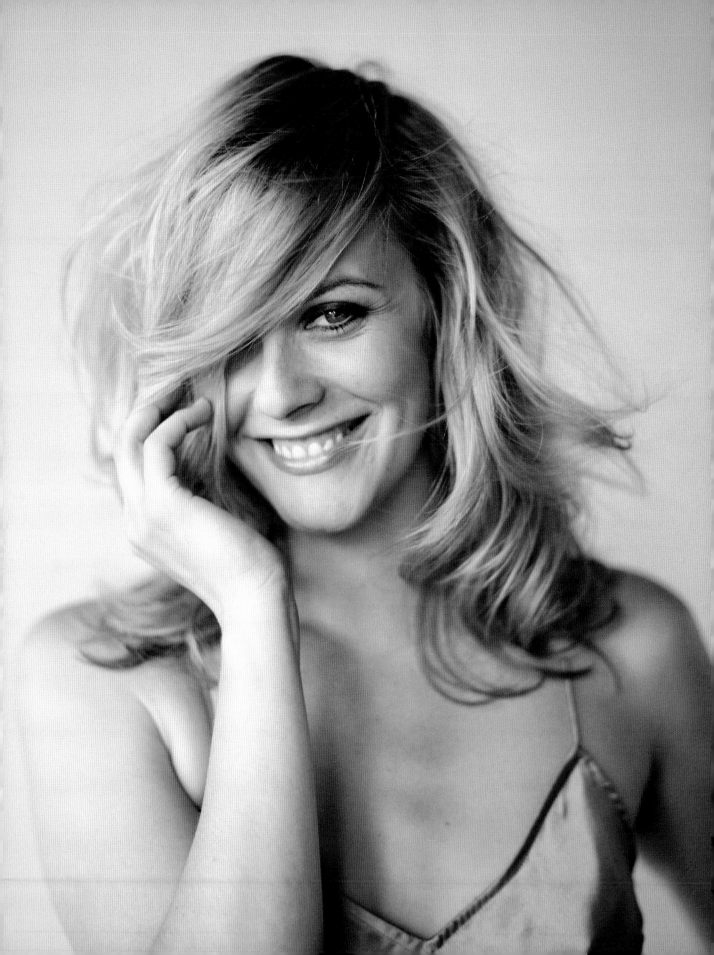

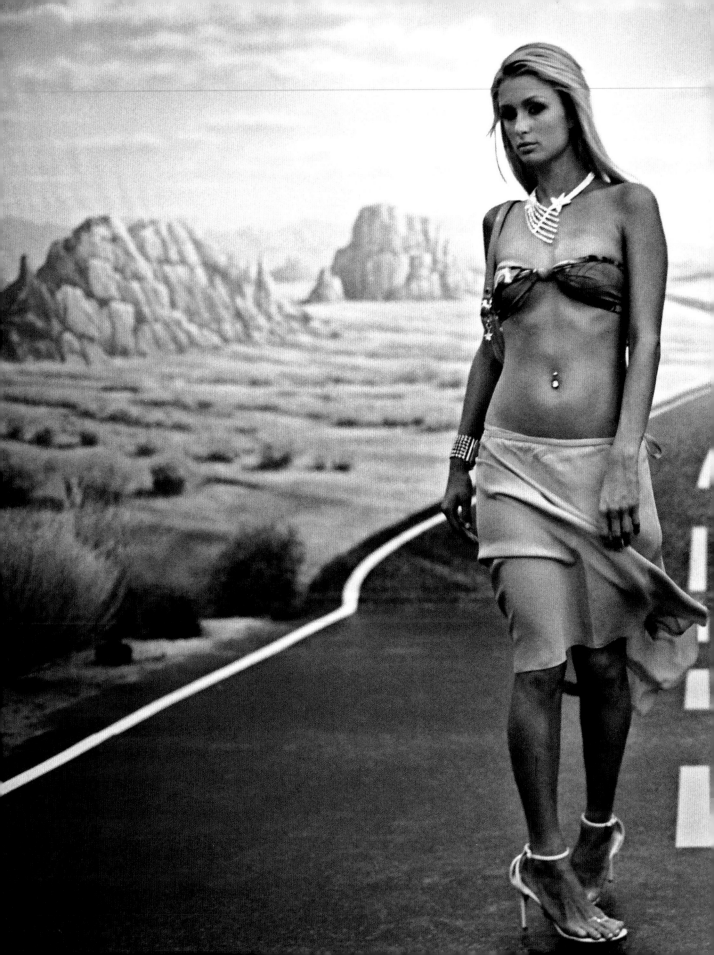

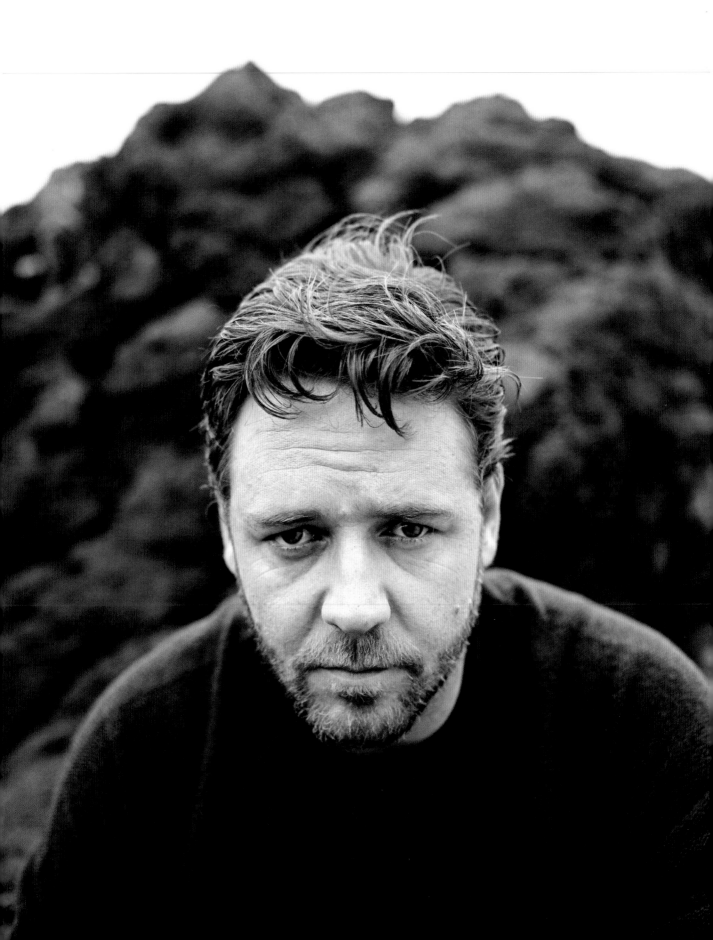

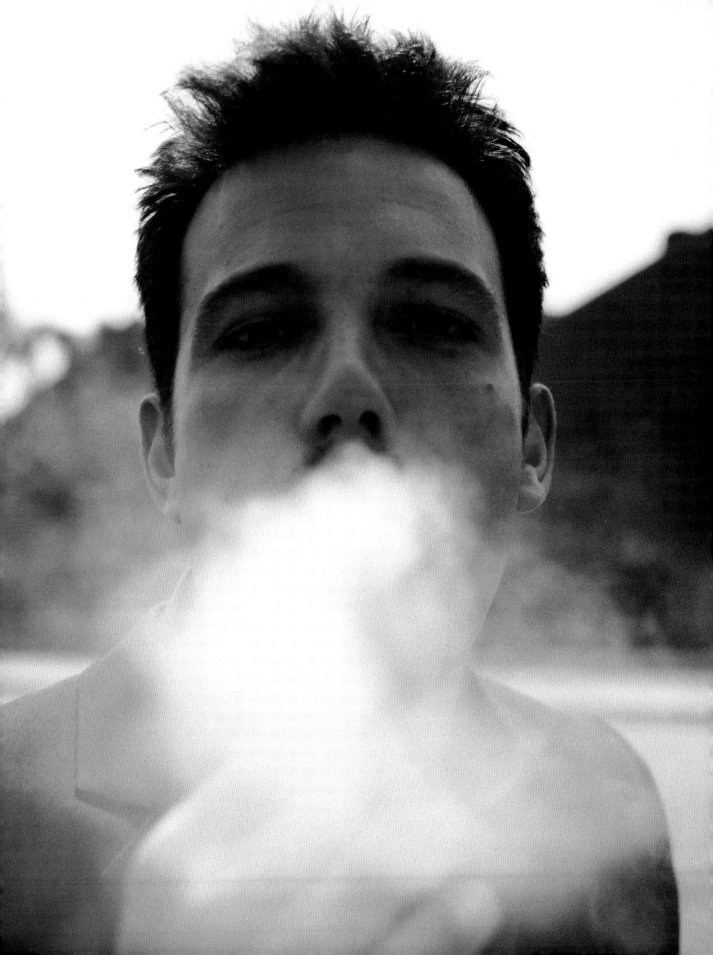

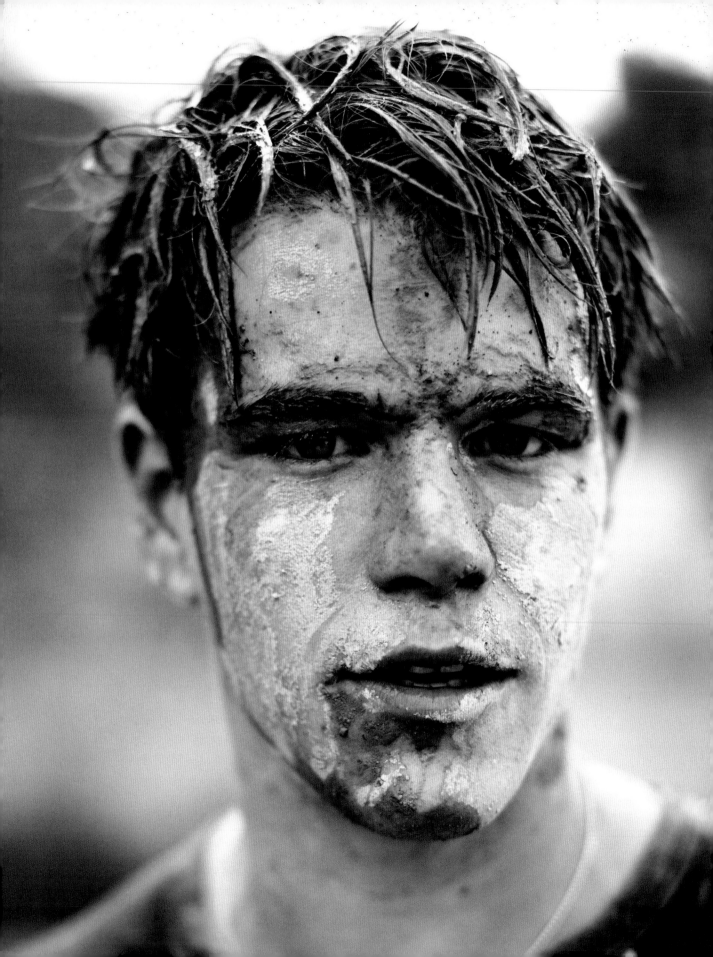

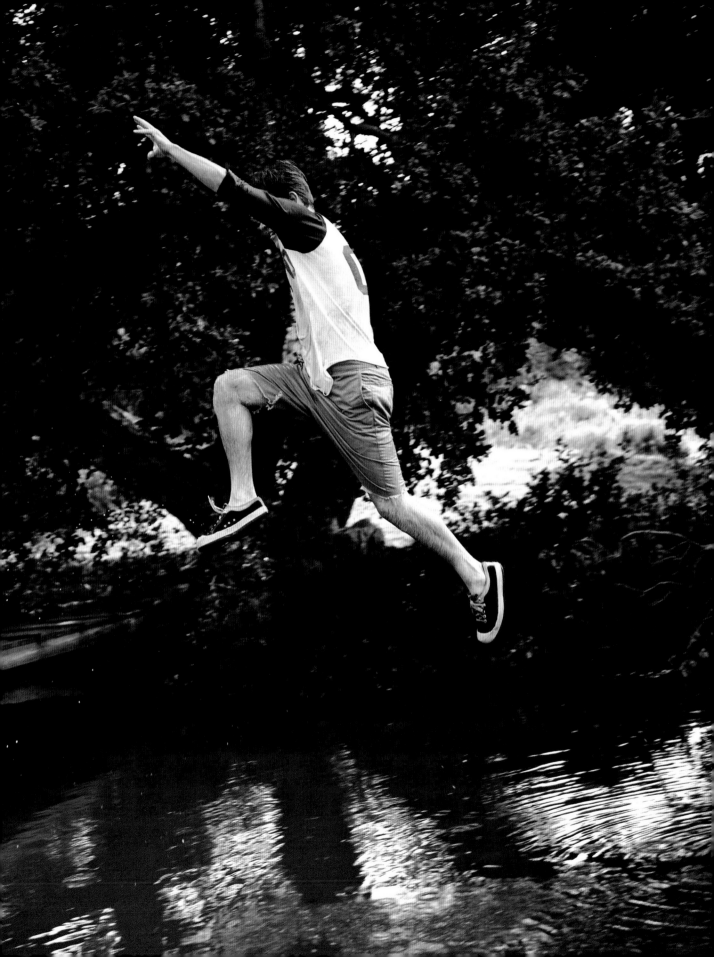

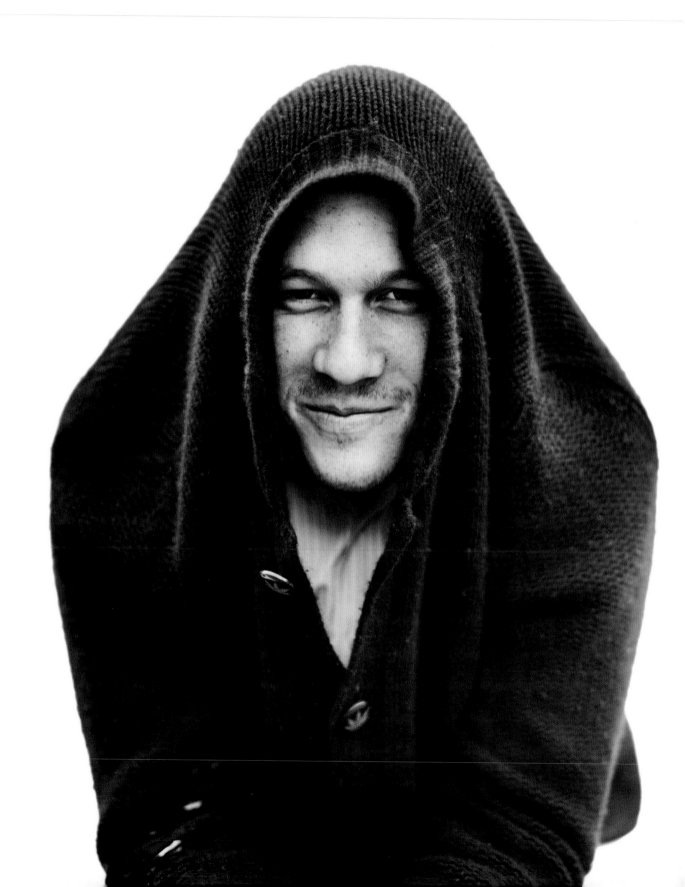

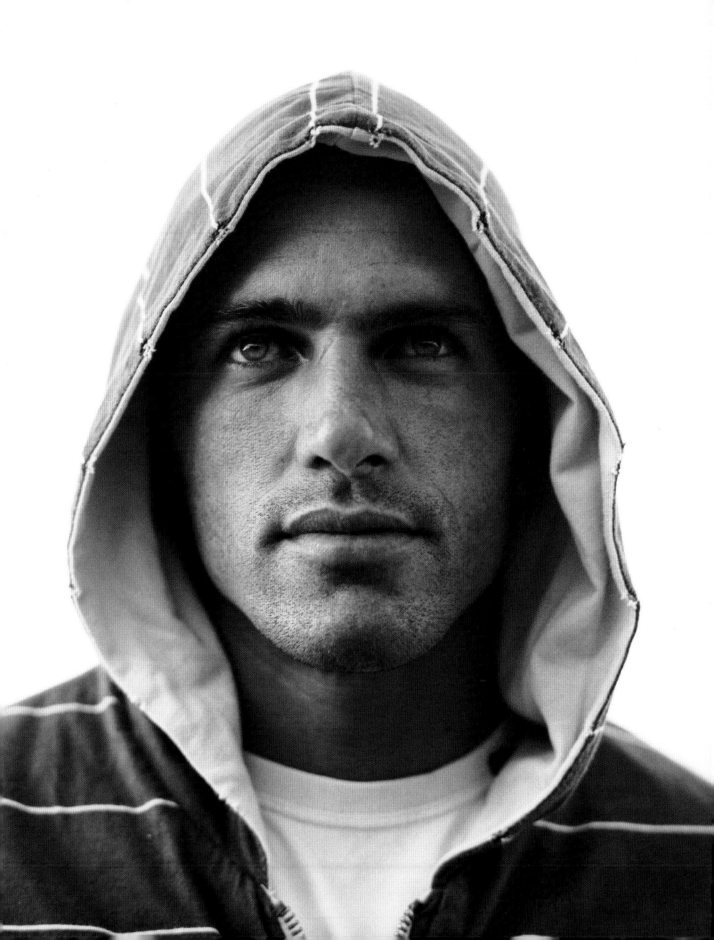

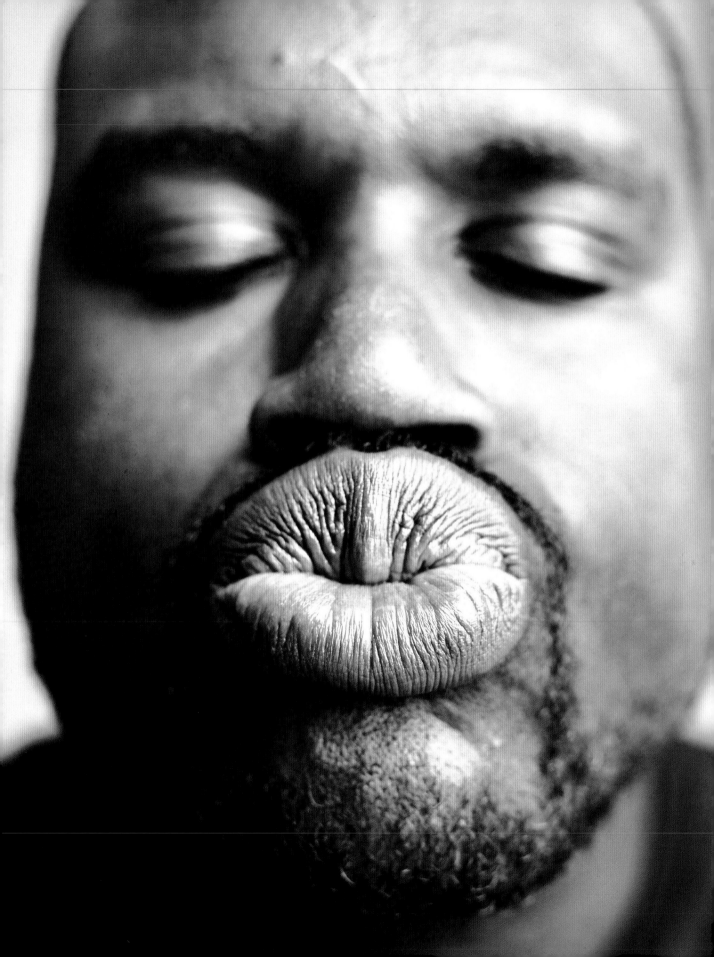

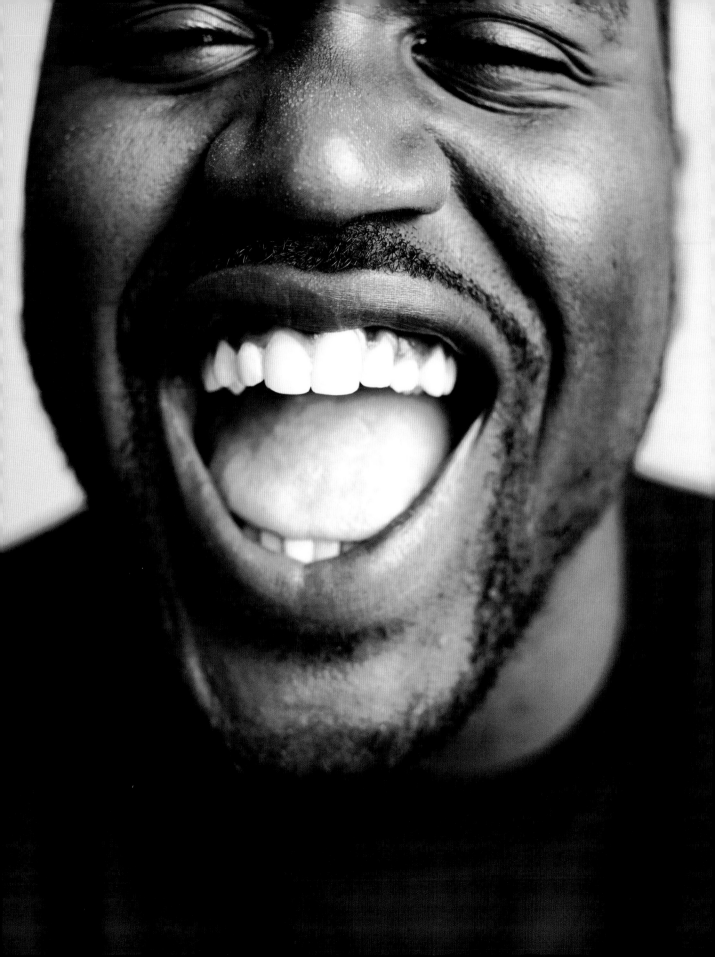

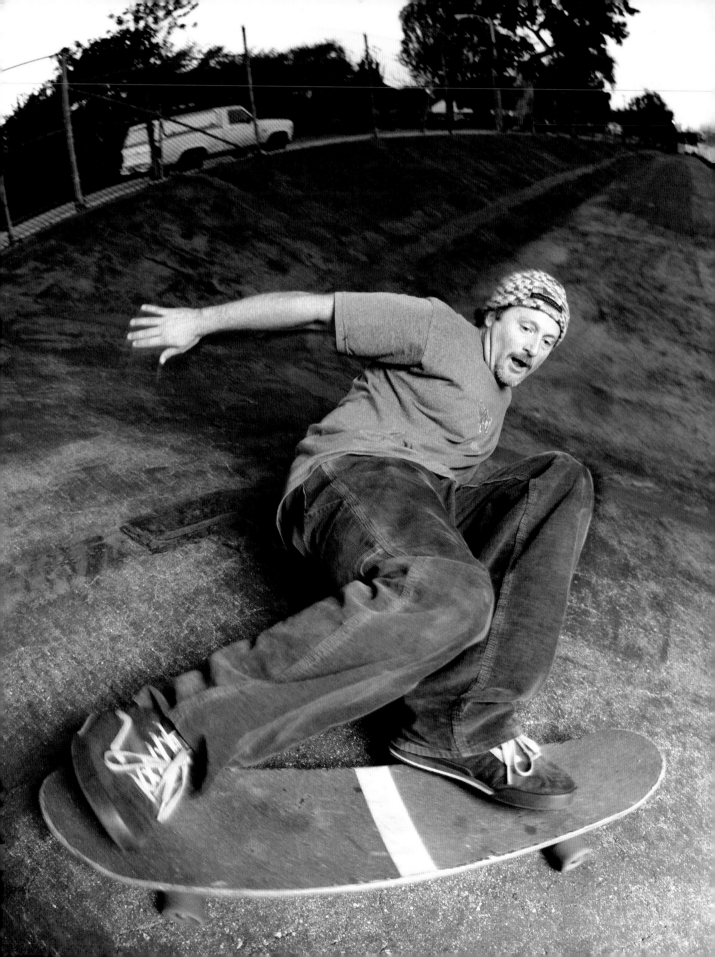

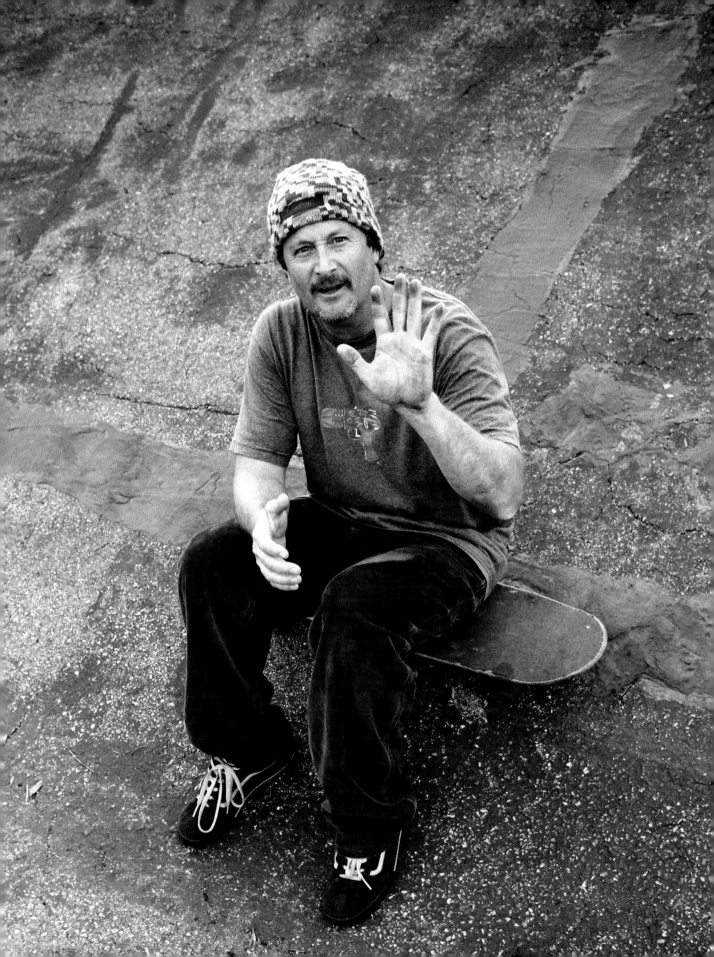

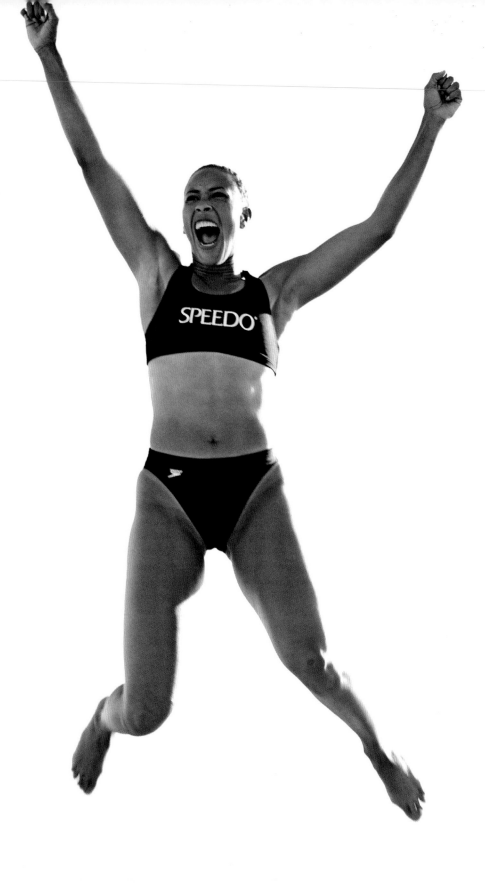

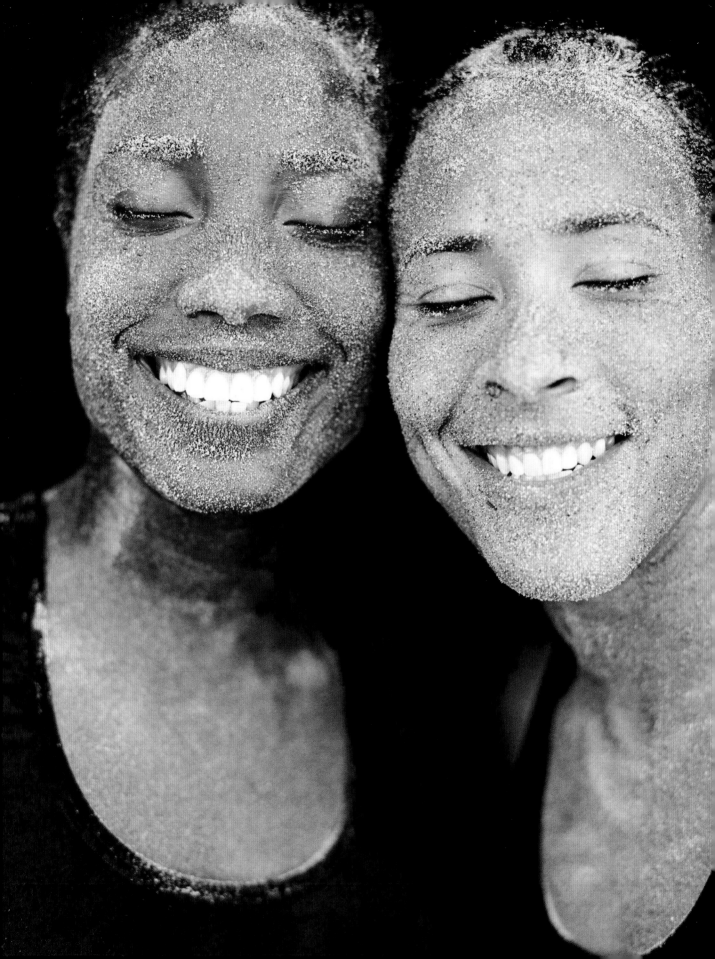

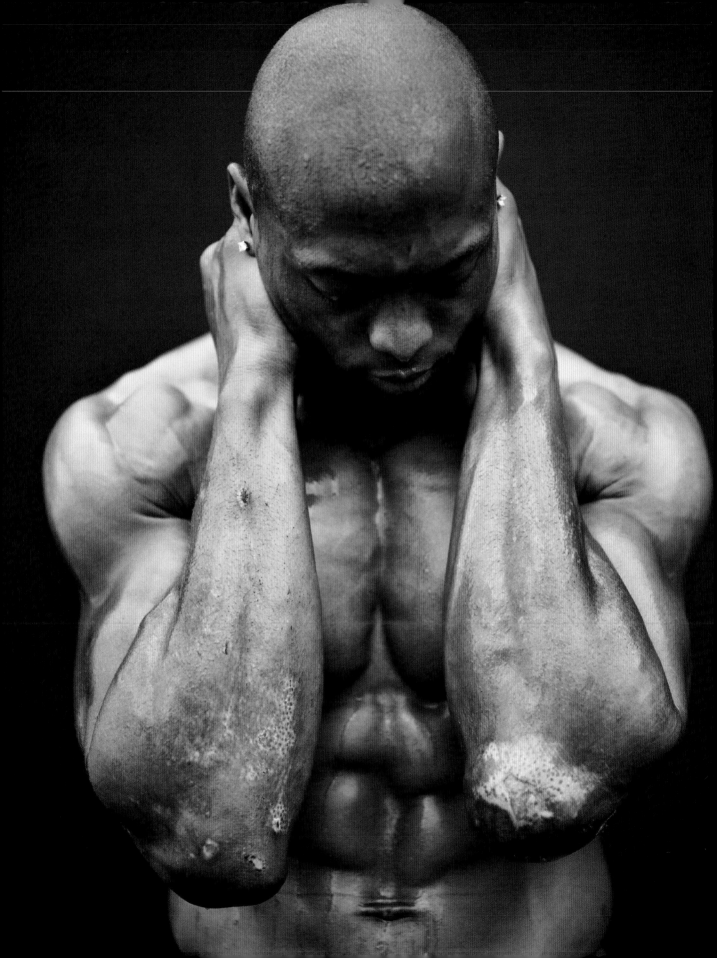

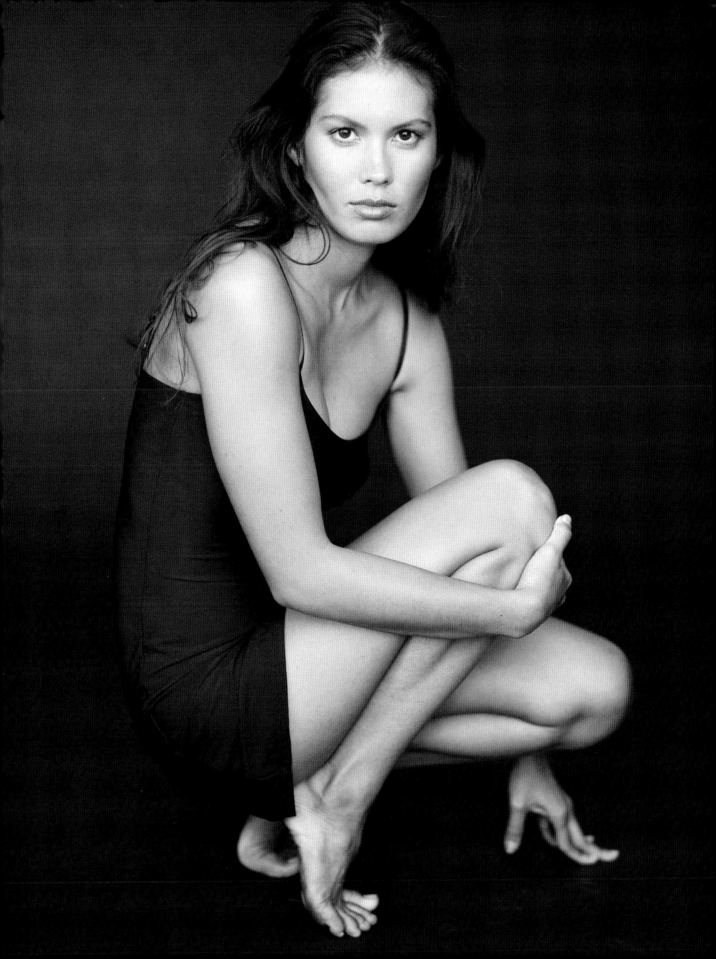

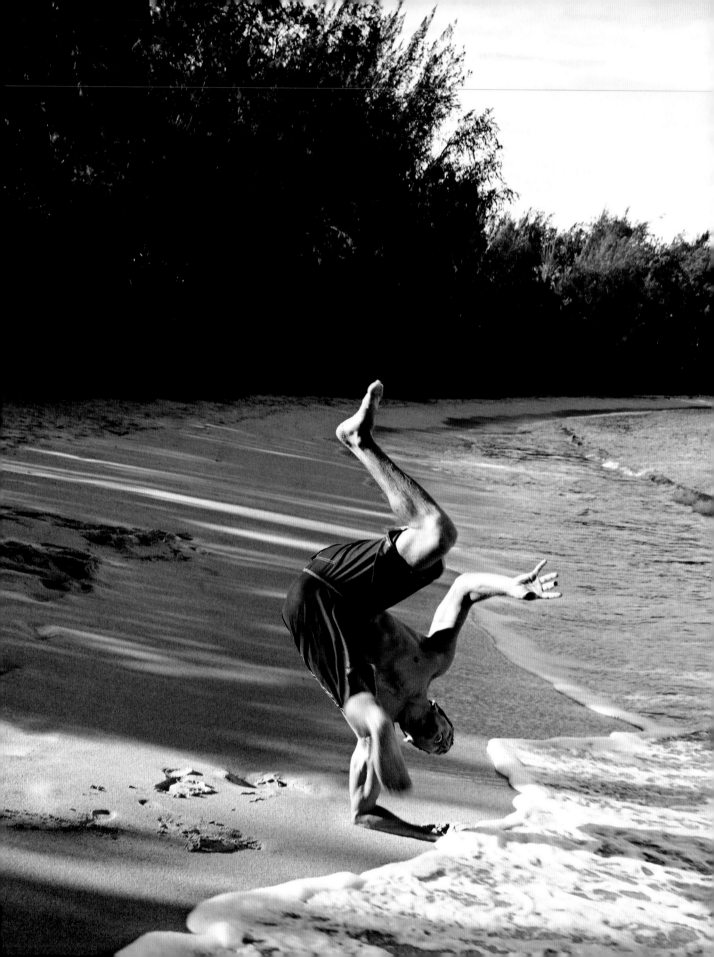

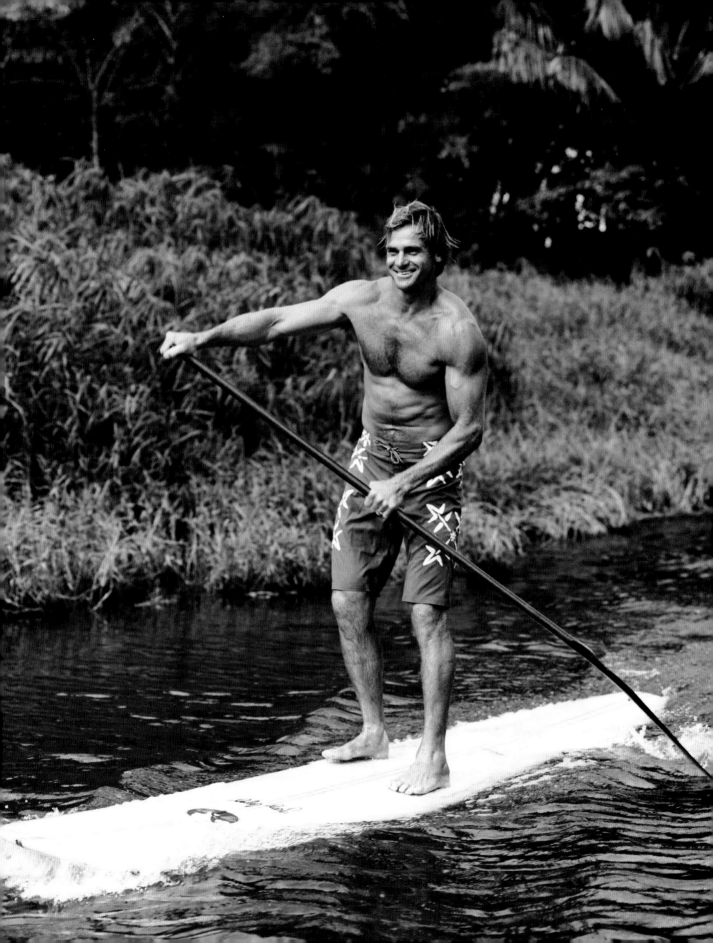

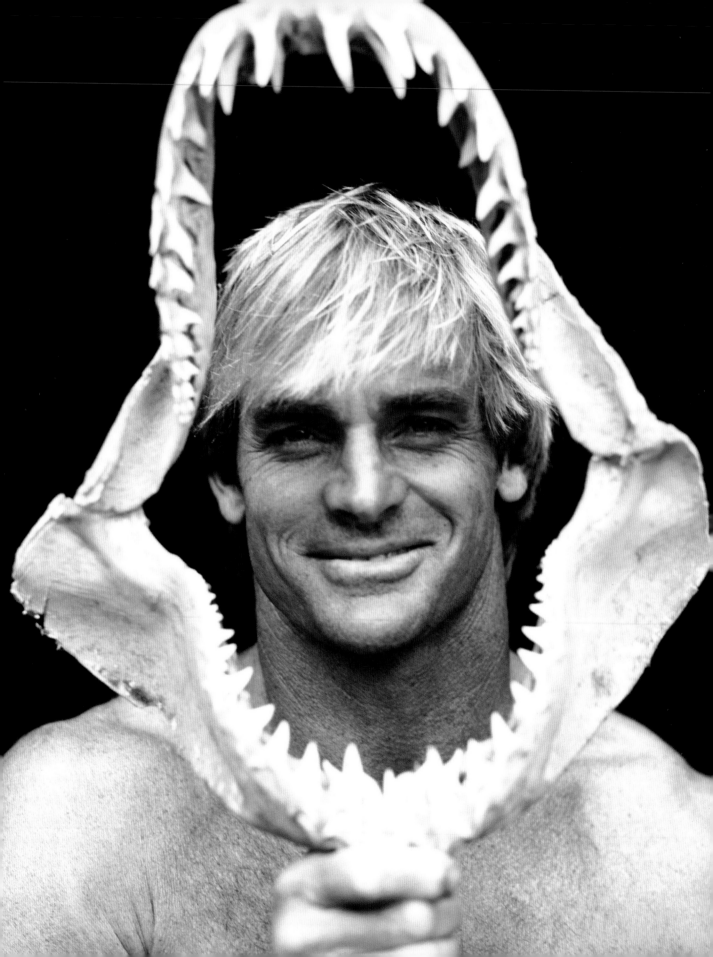

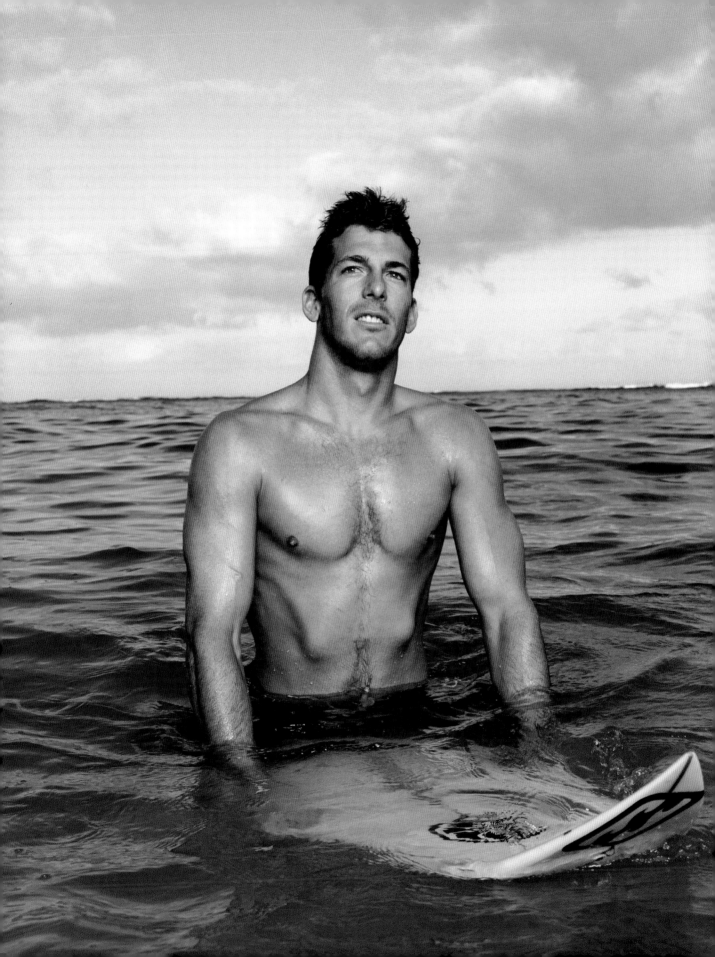

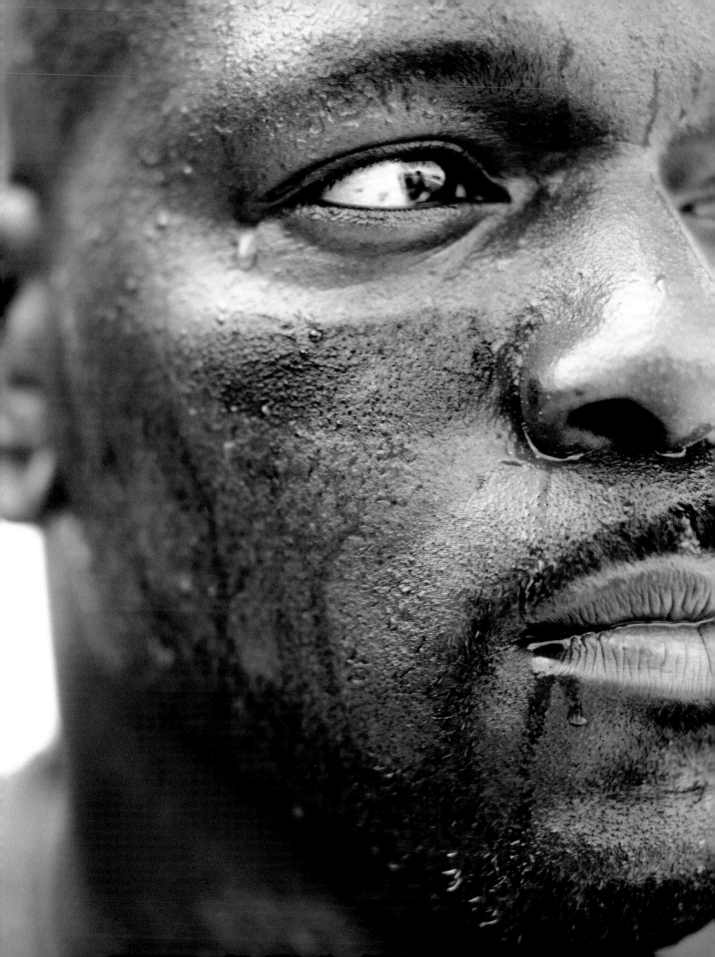

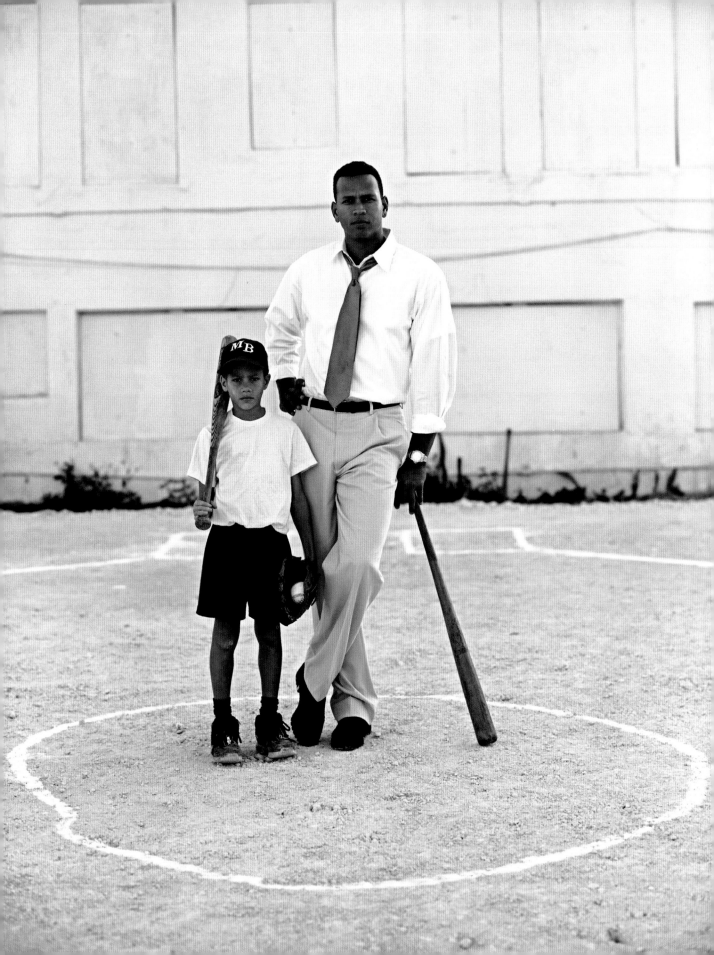

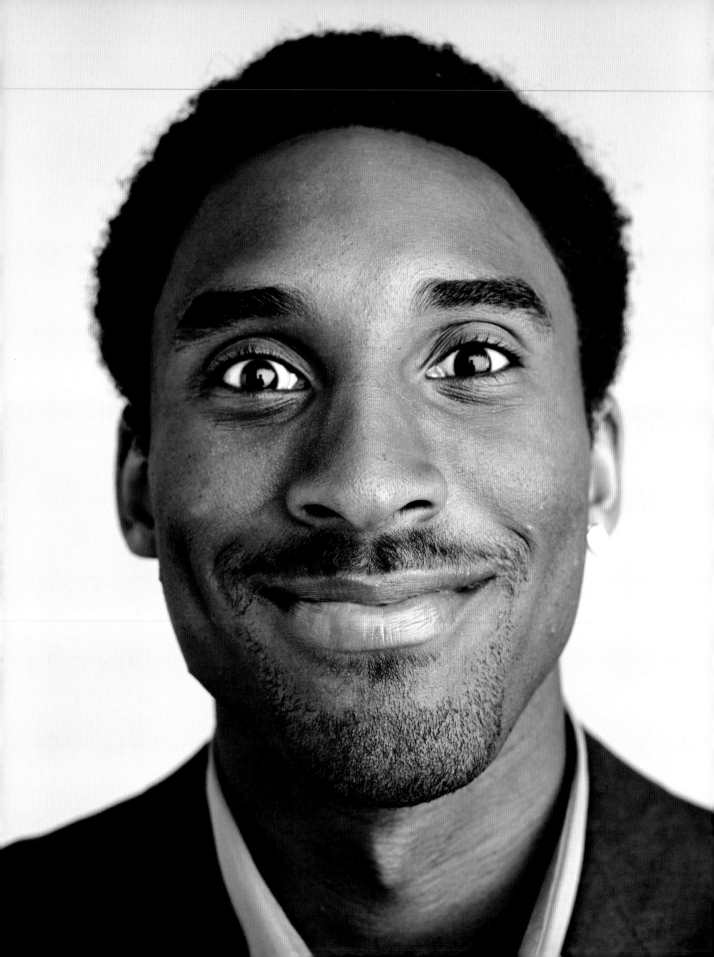

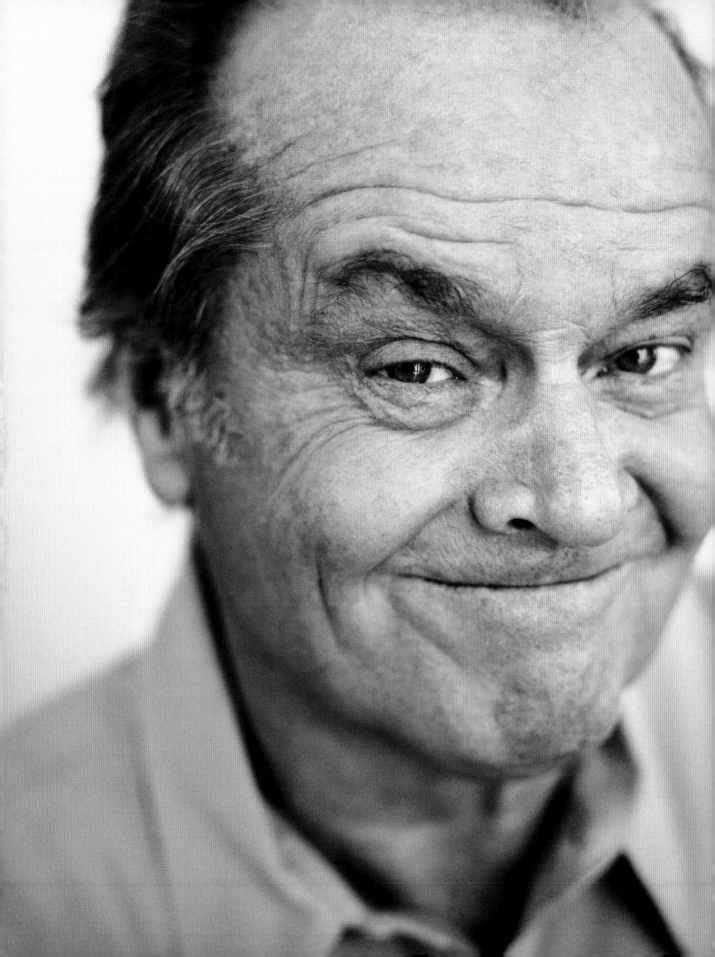

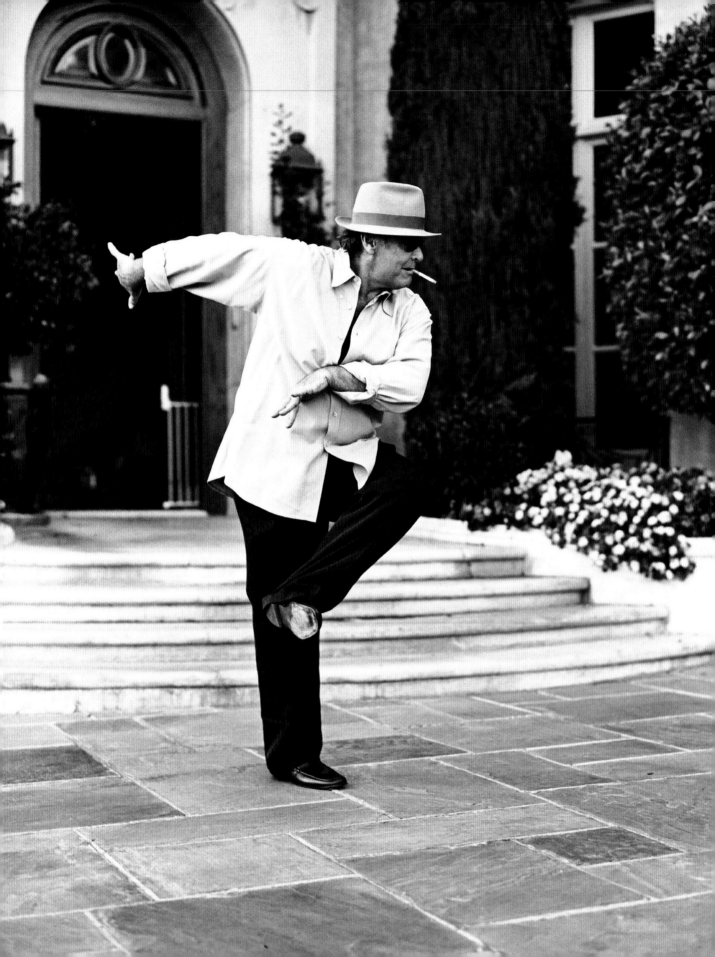

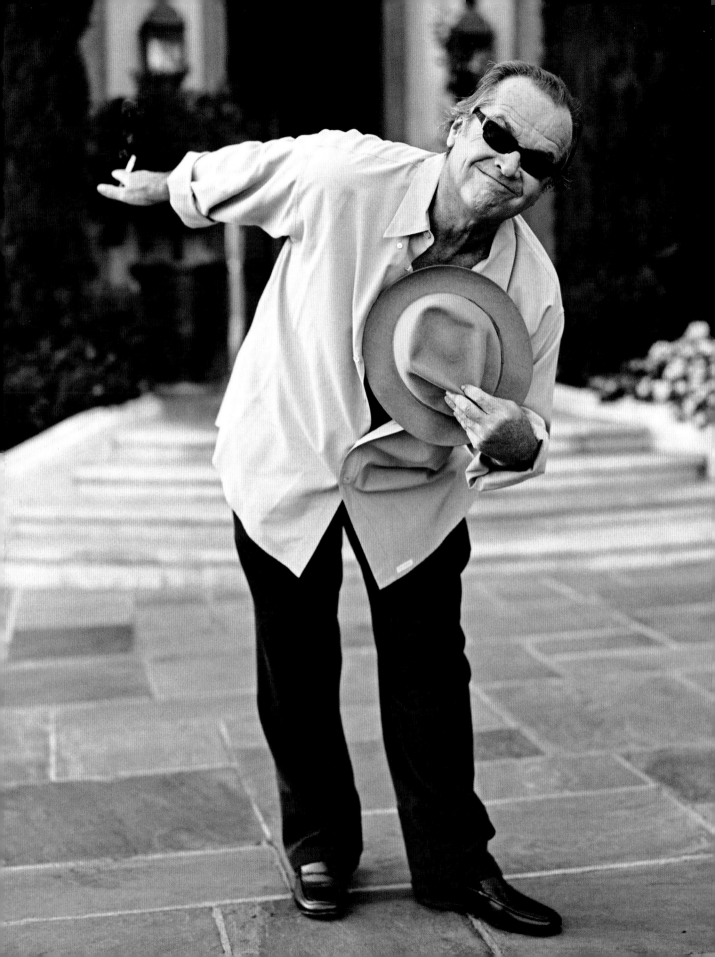

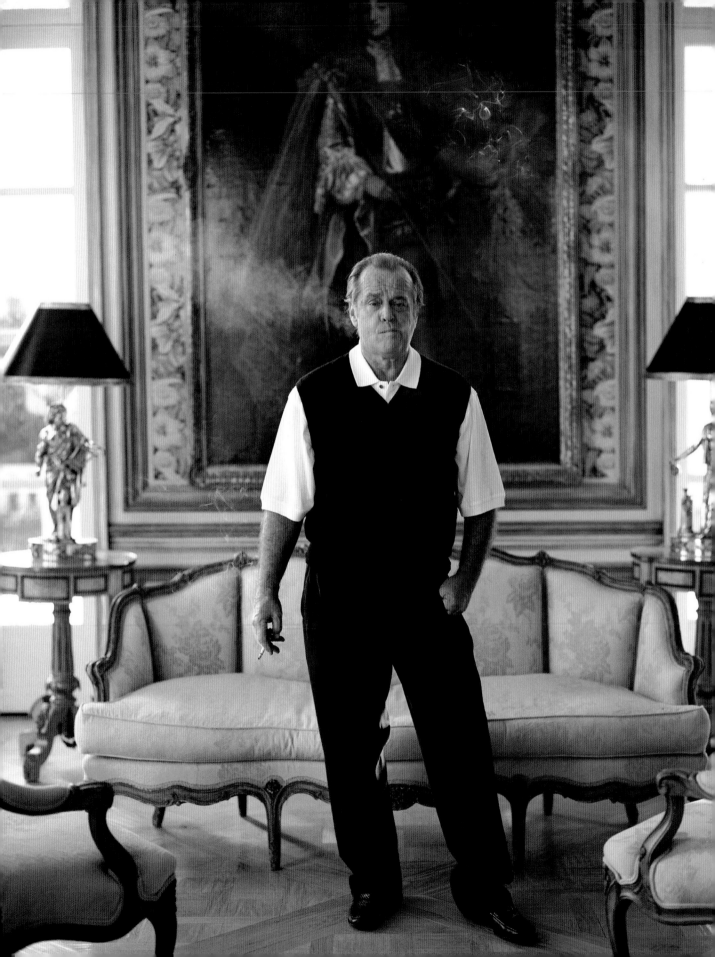

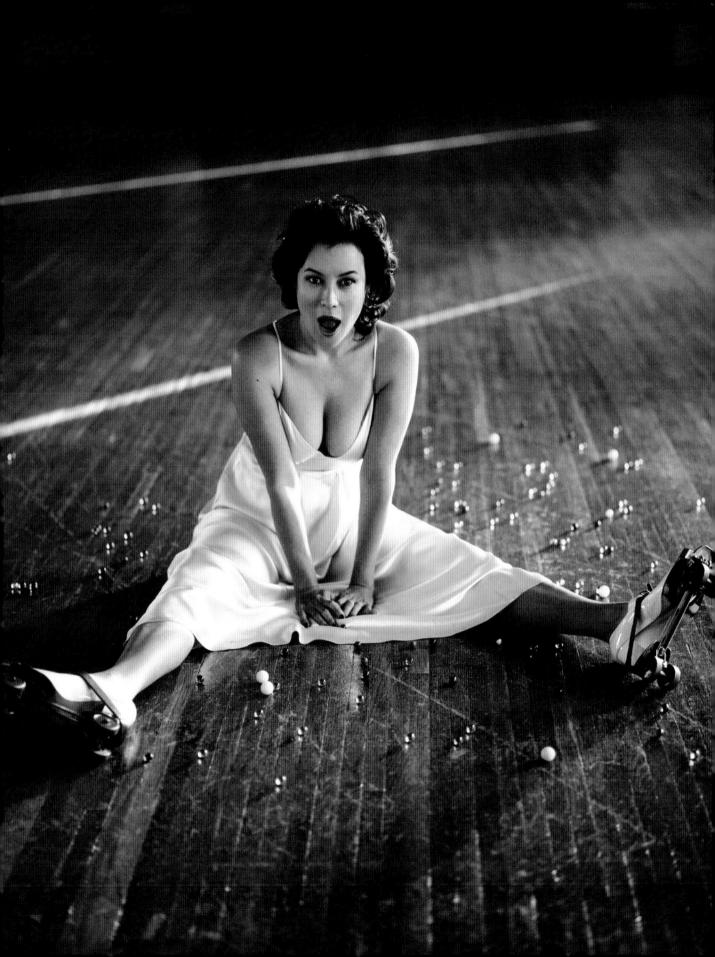

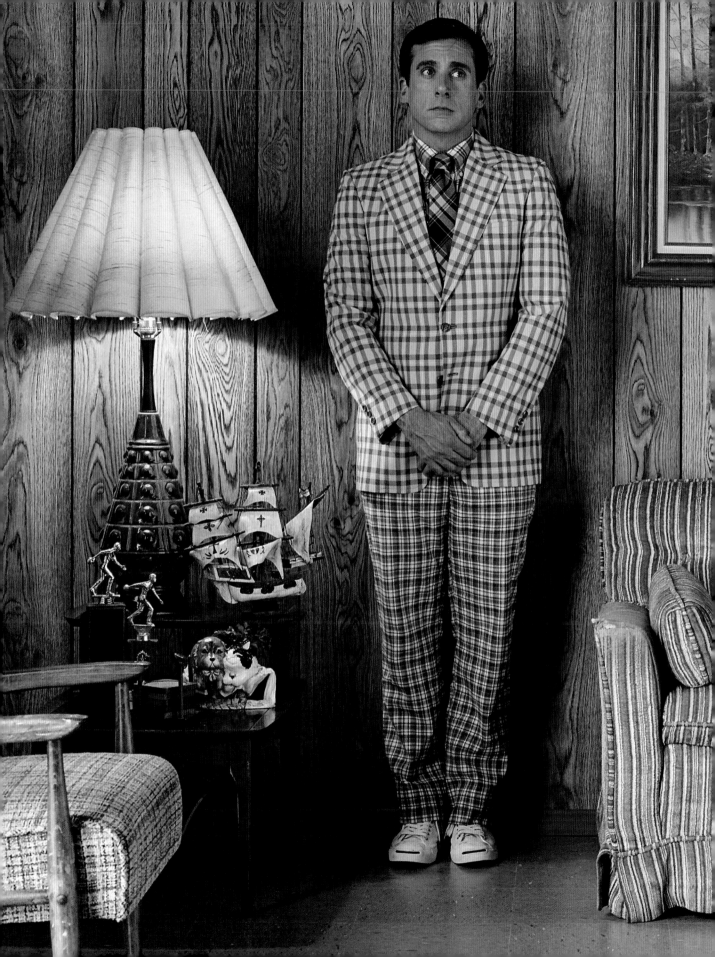

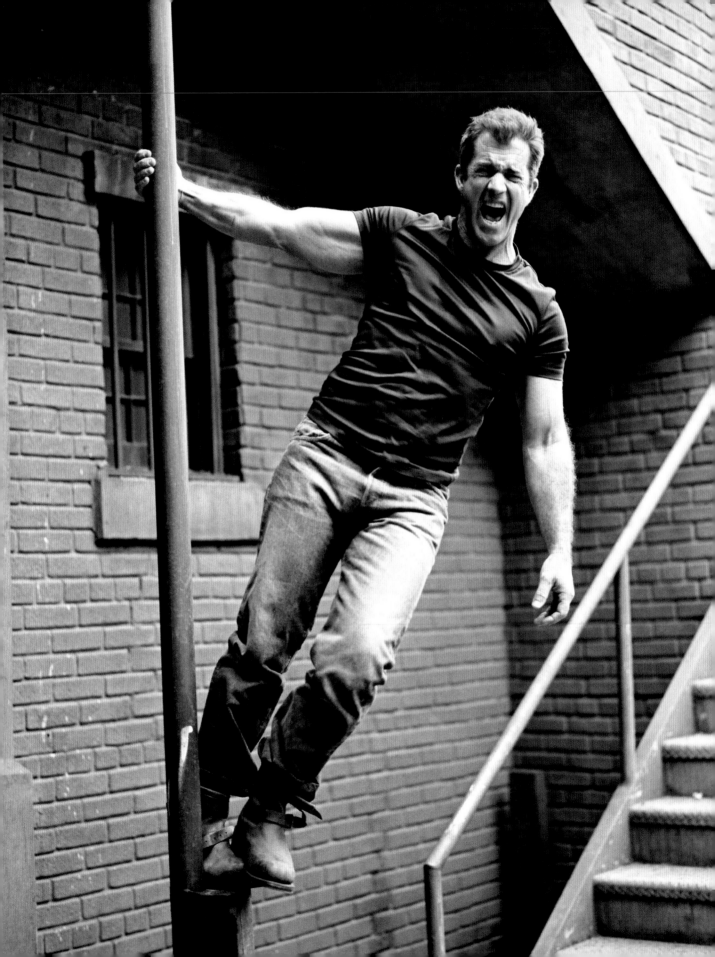

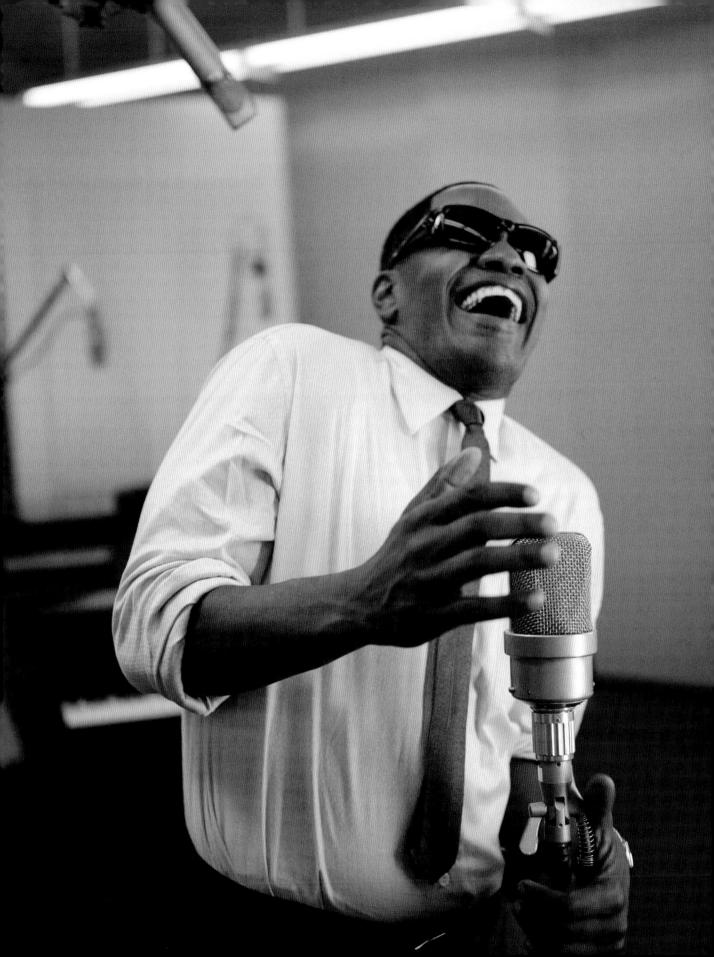

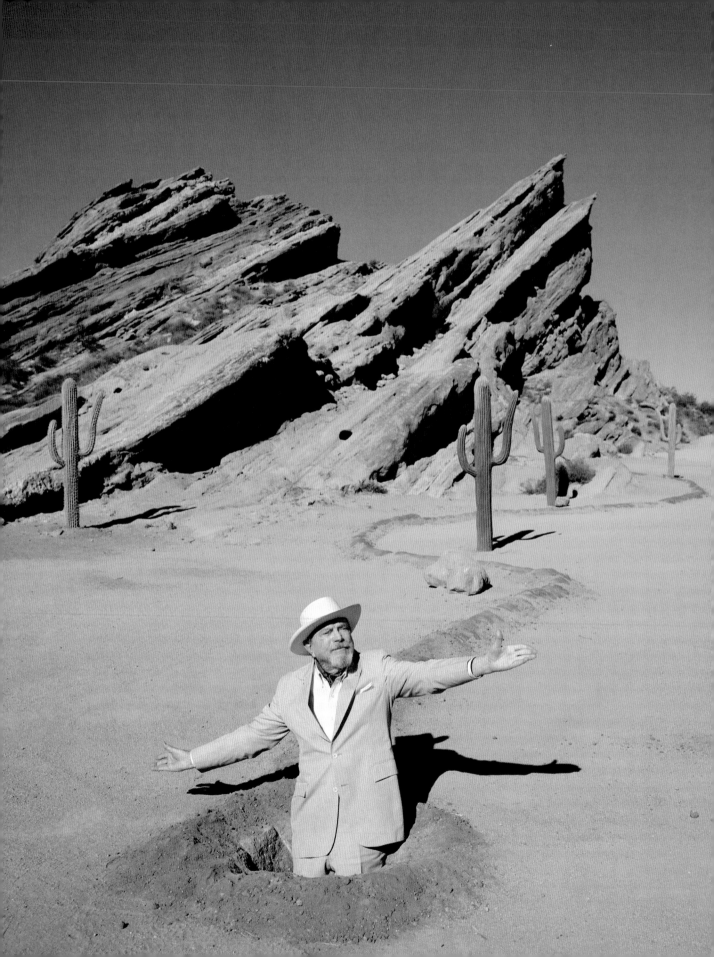

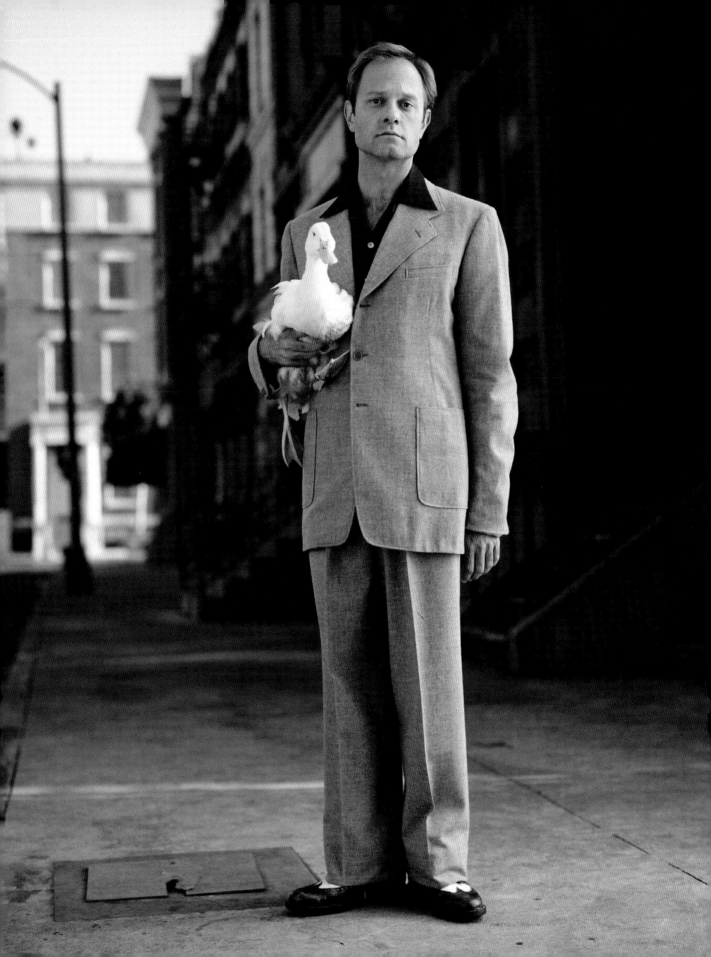

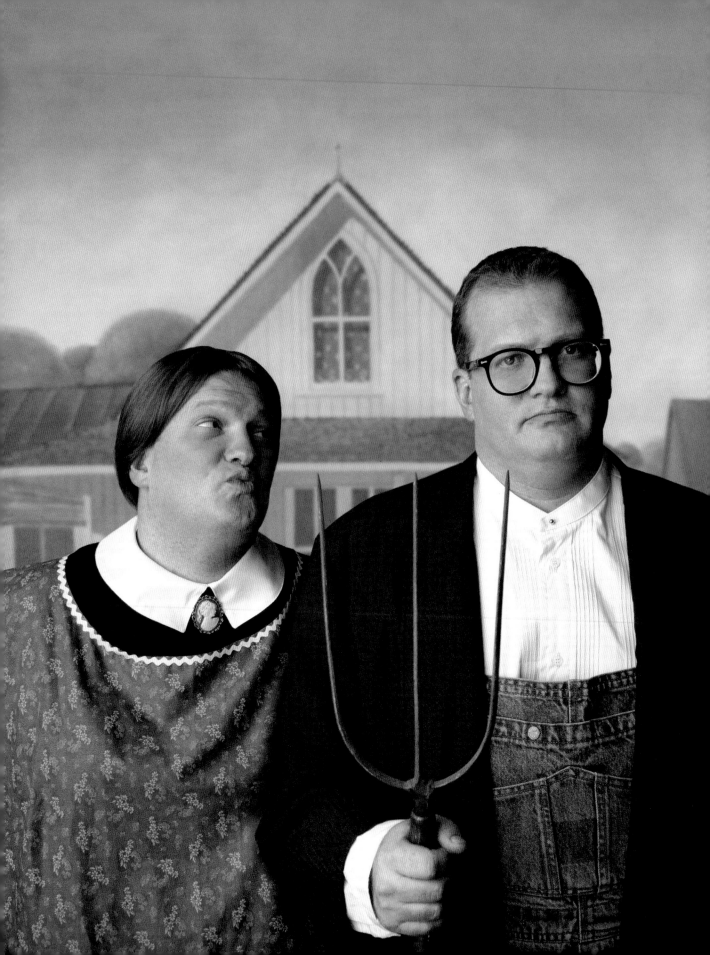

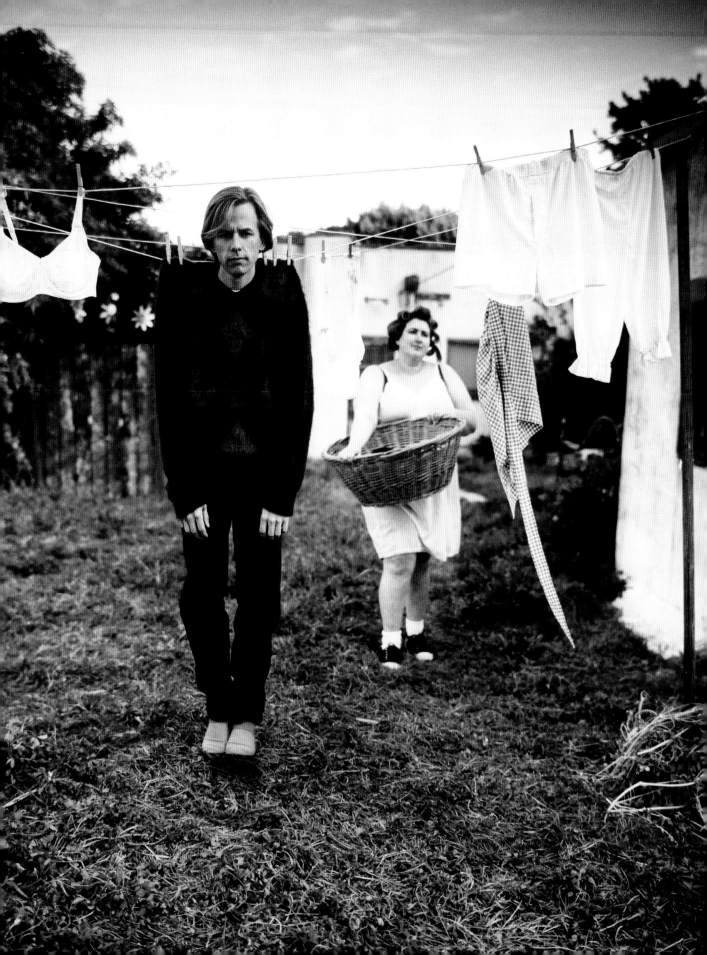

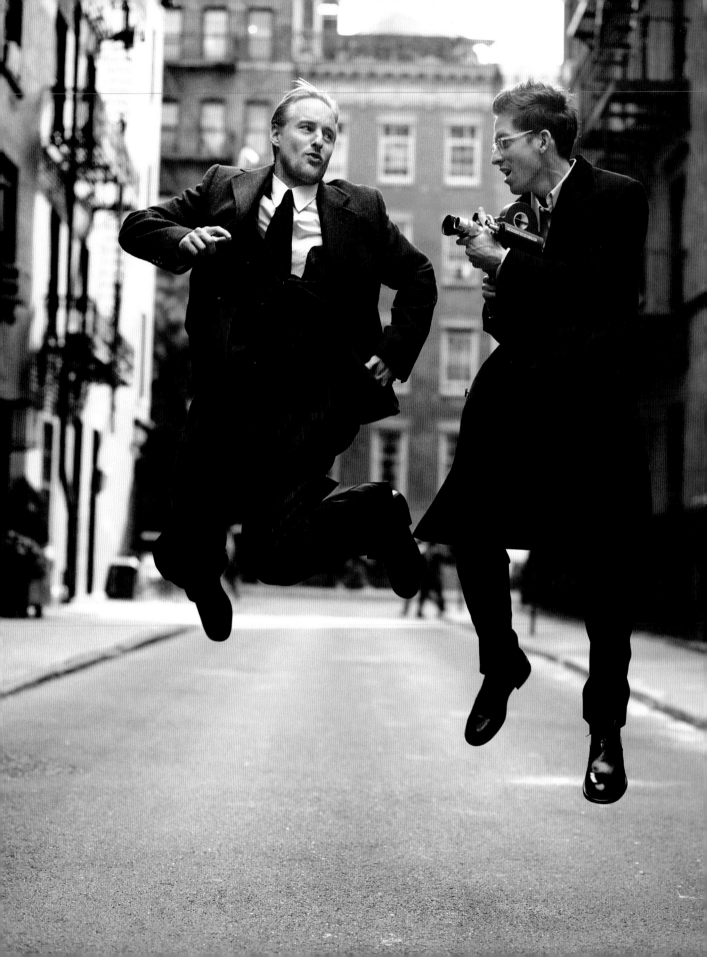

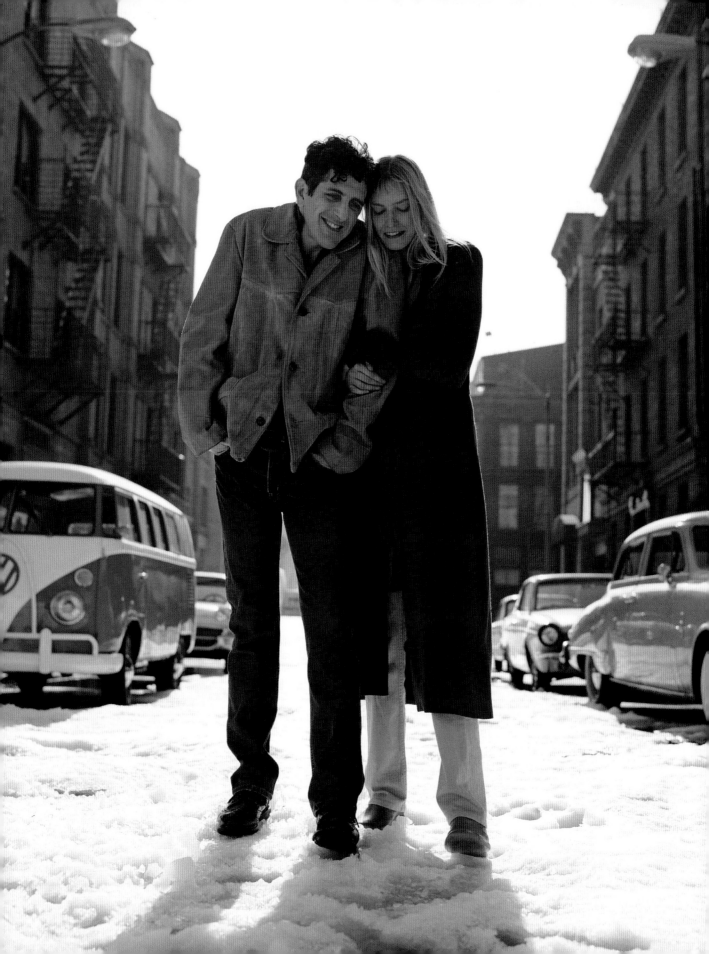

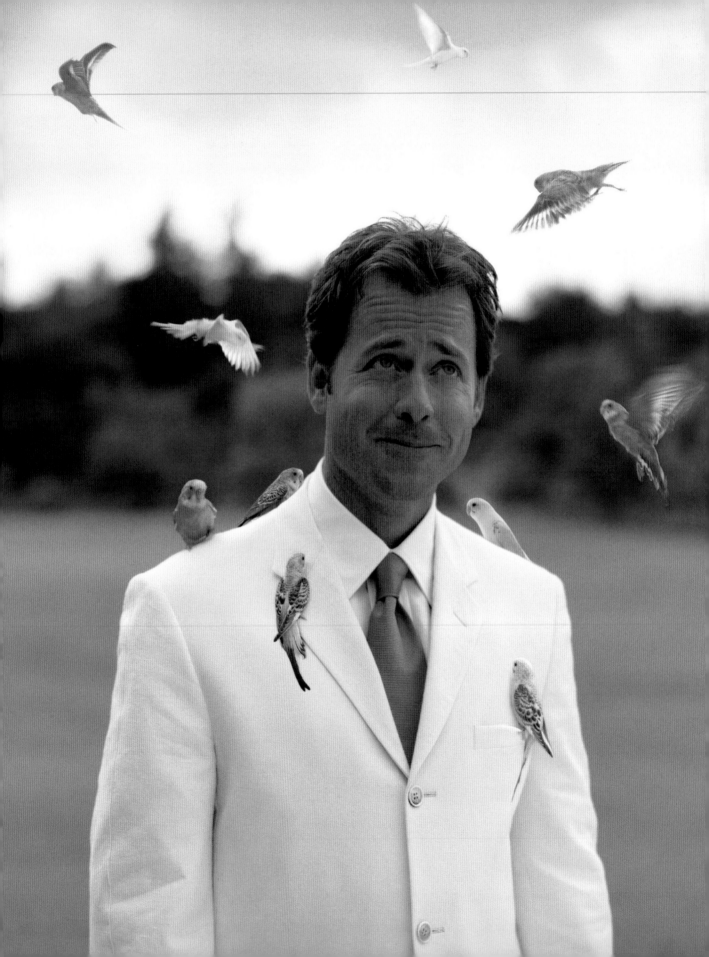

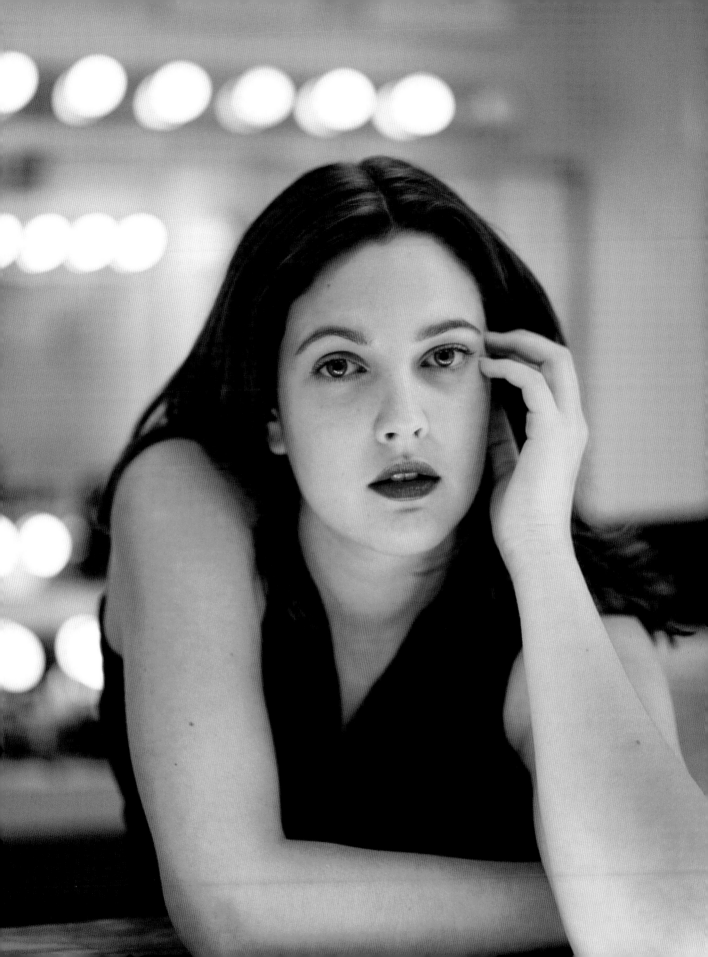

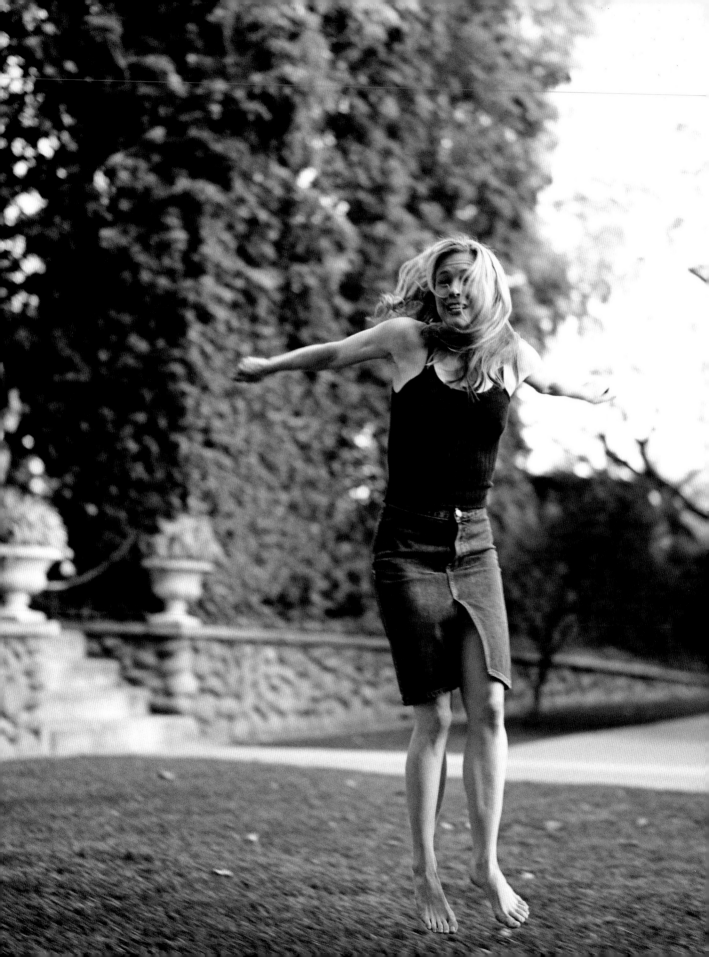

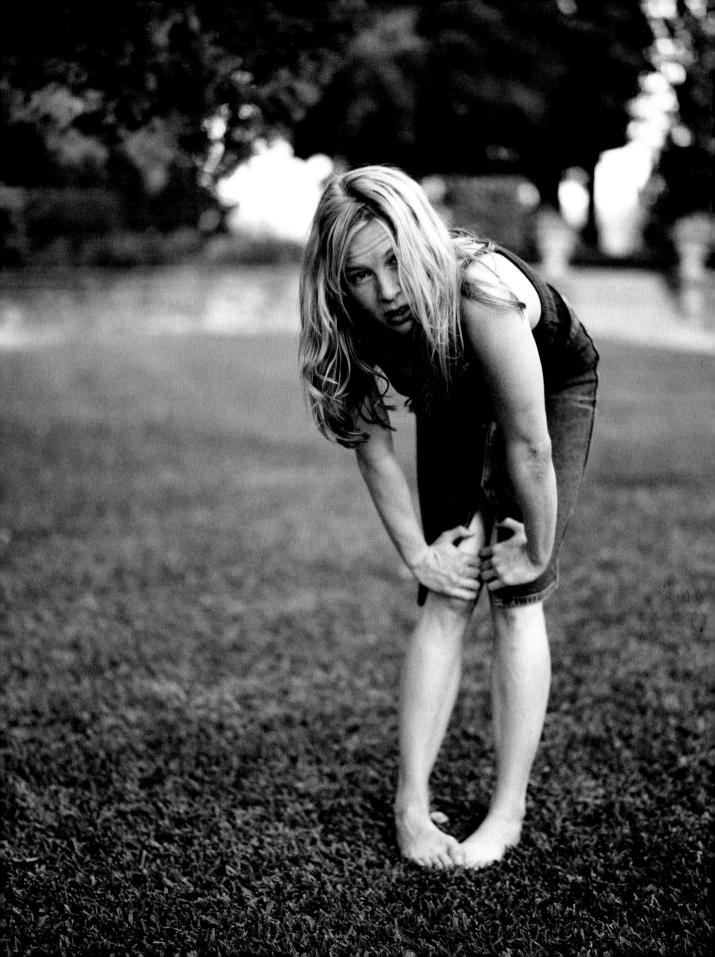

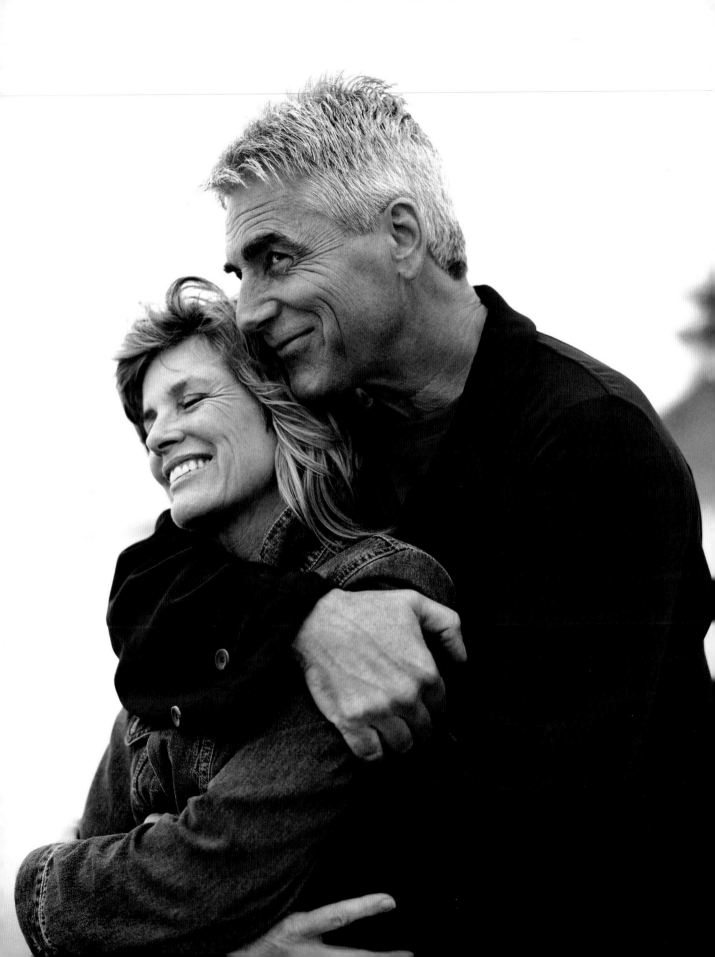

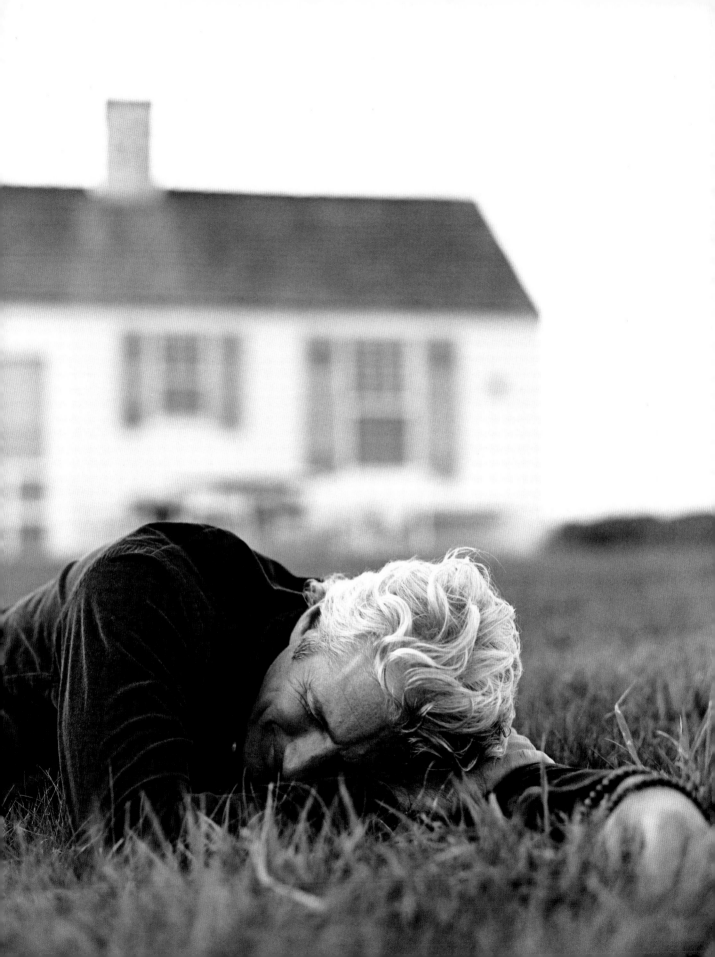

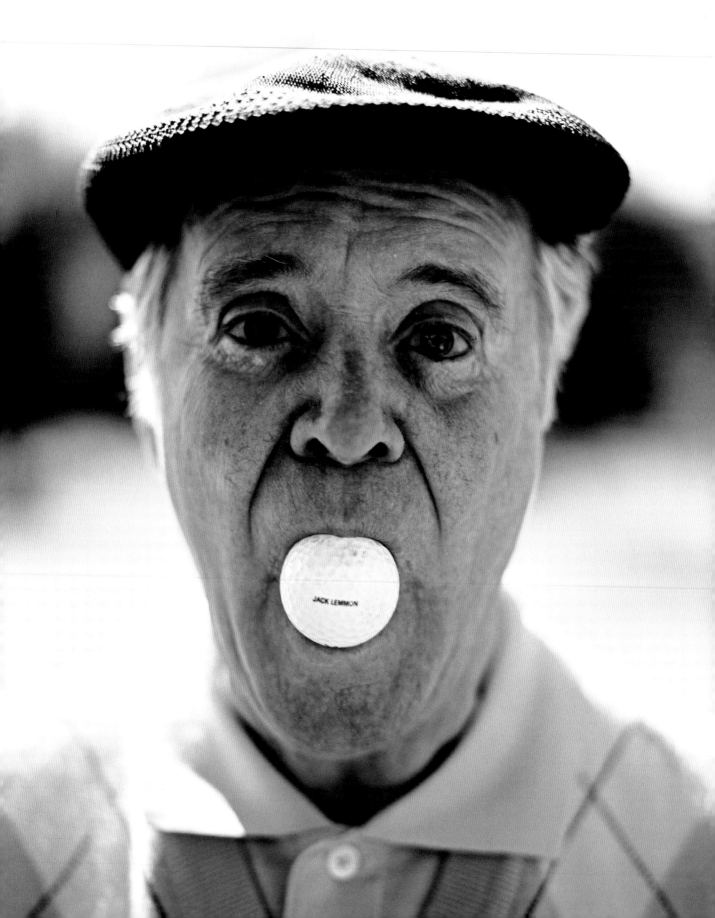

JACK LEMMON

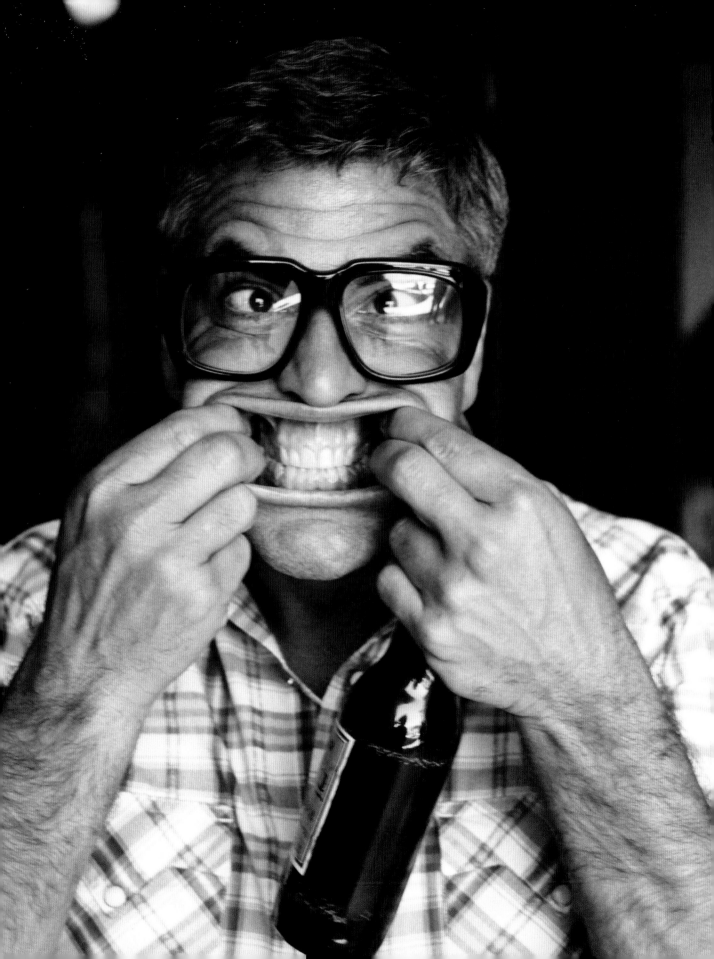

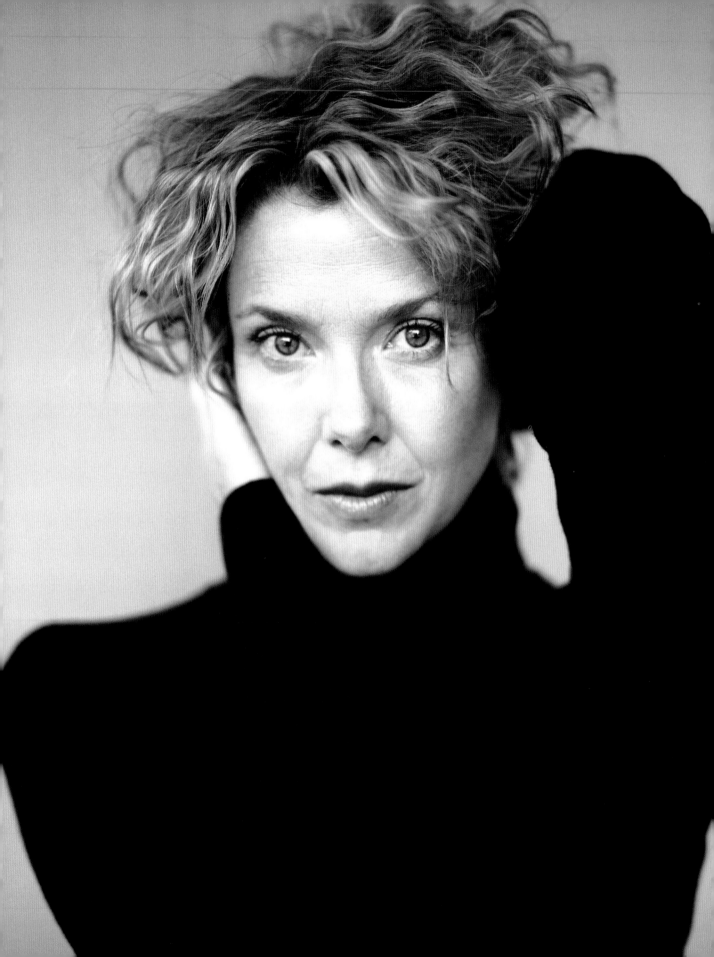

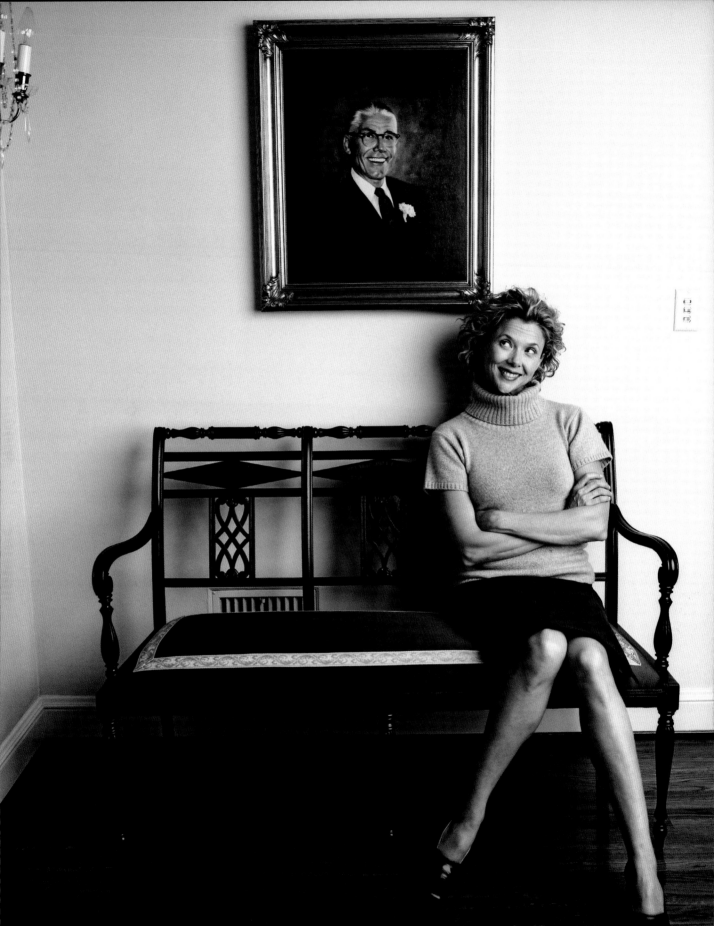

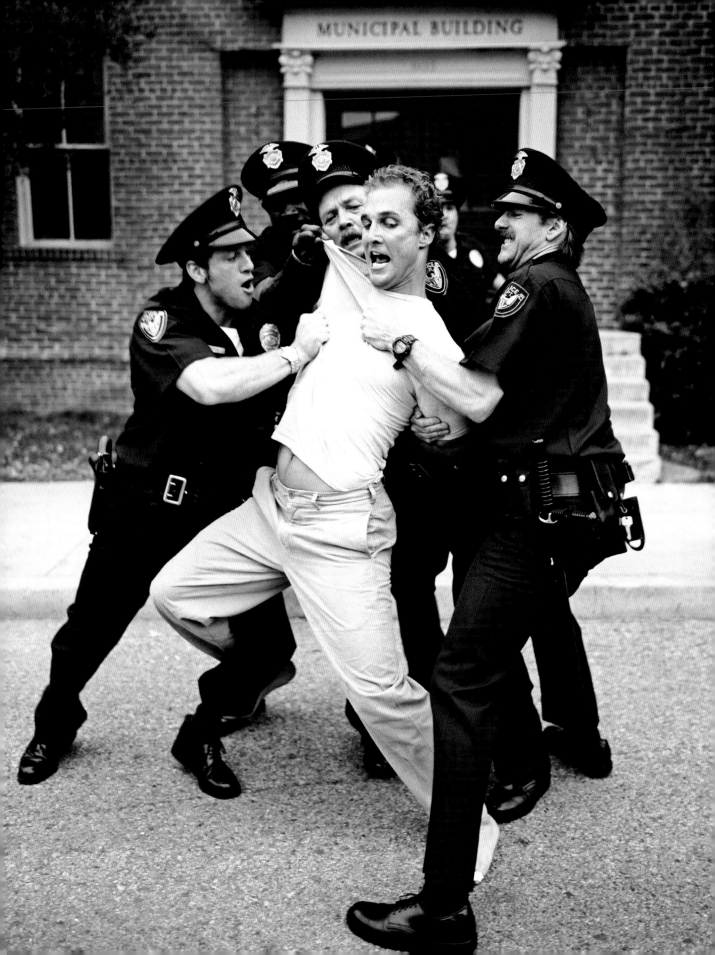

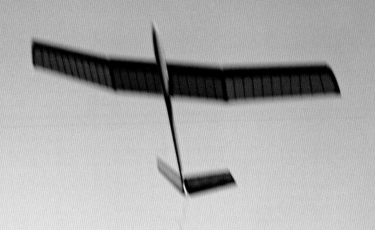
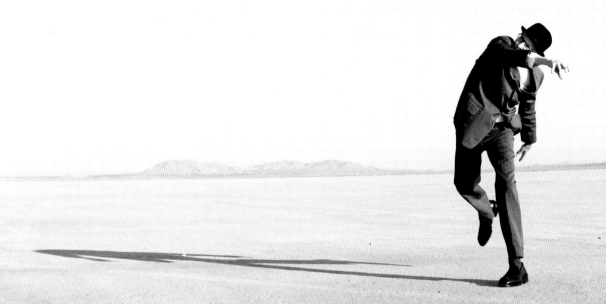

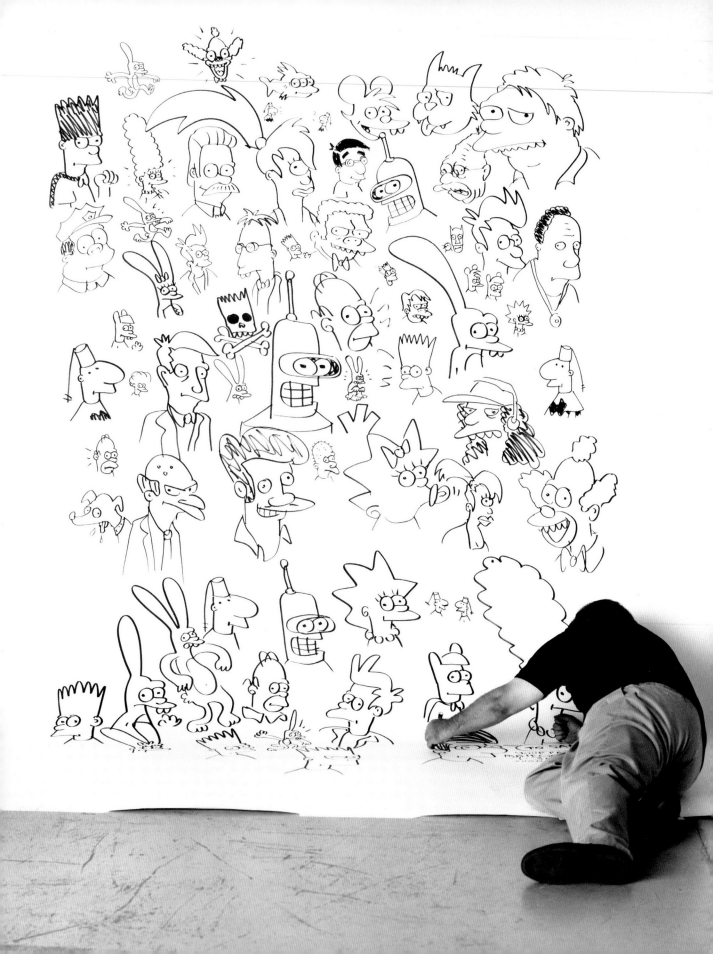

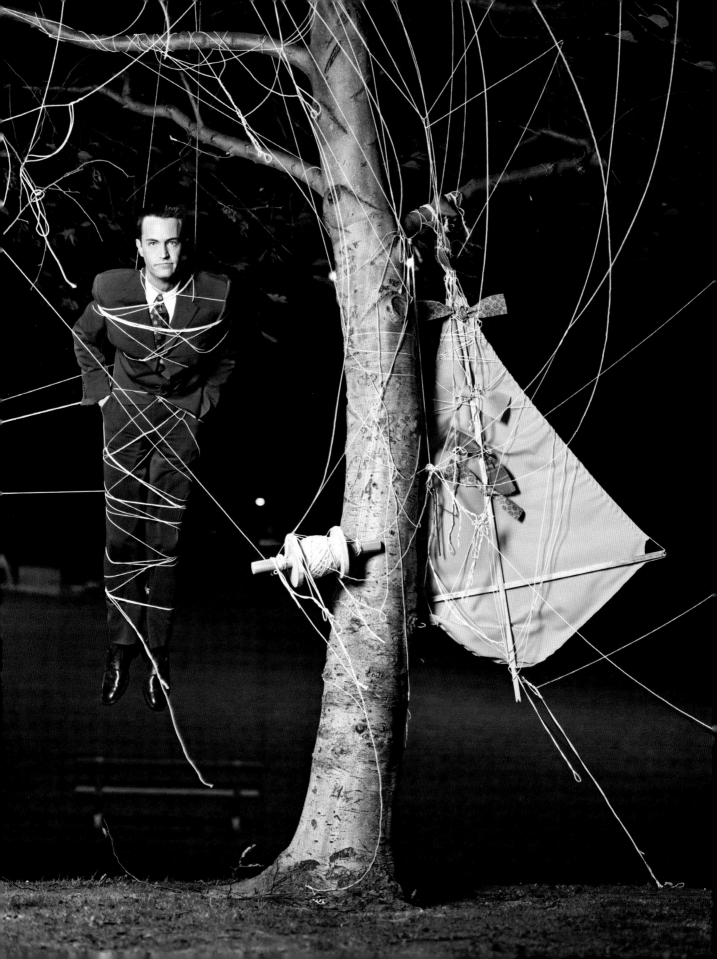

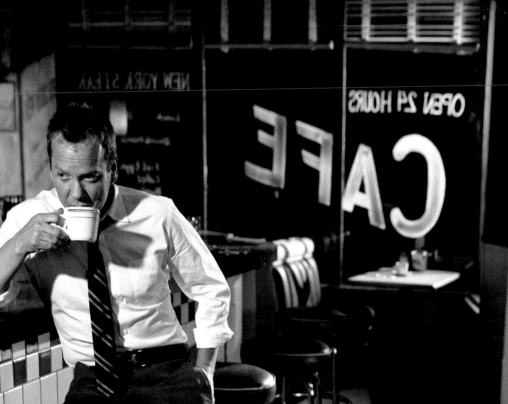

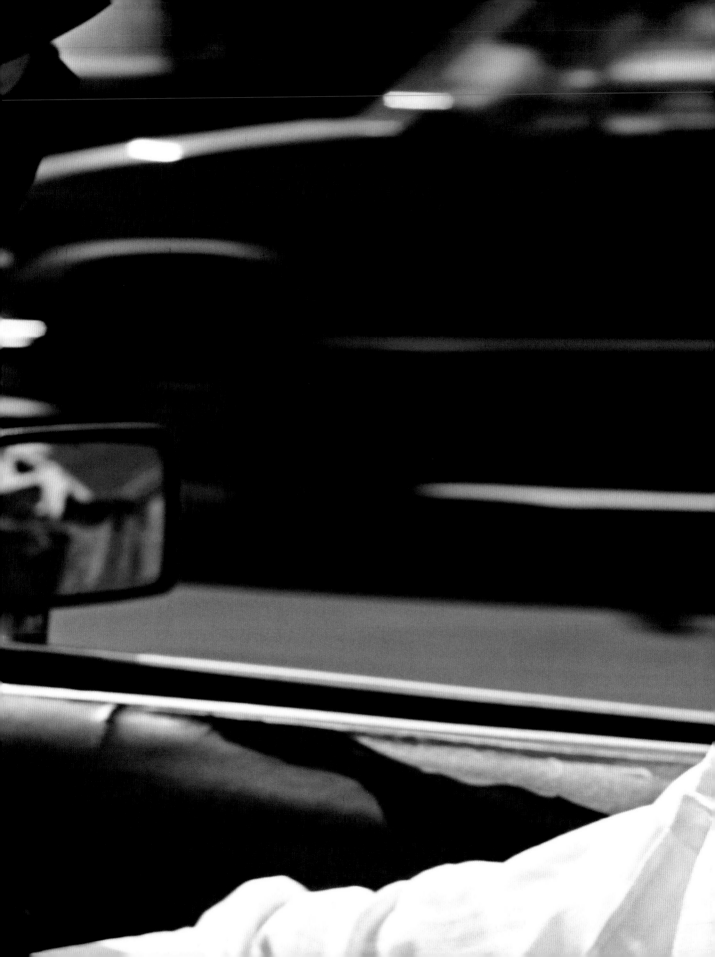

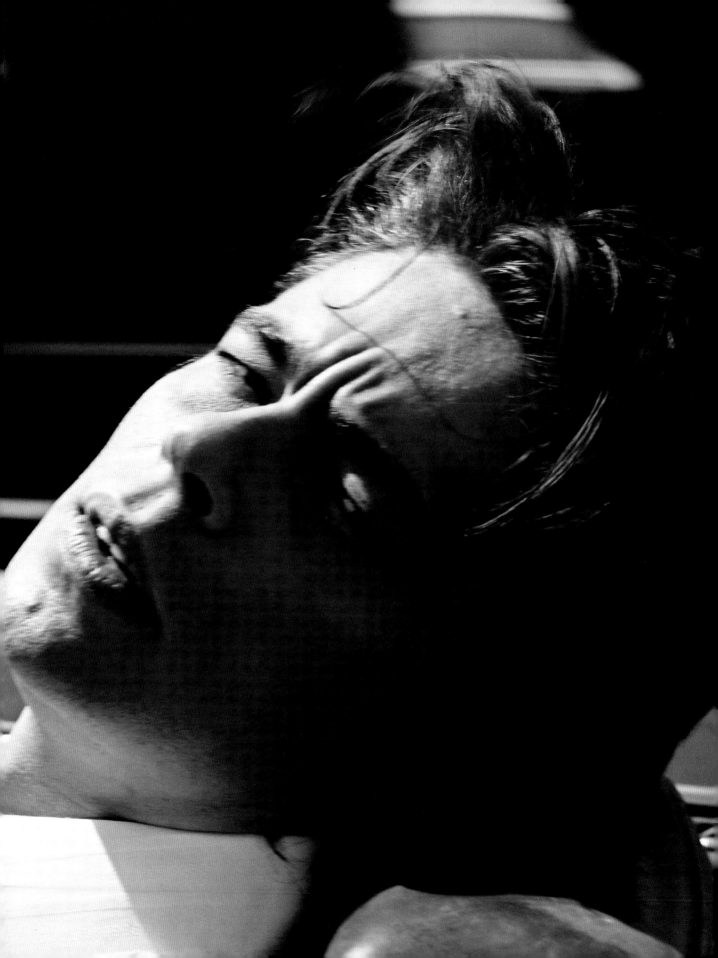

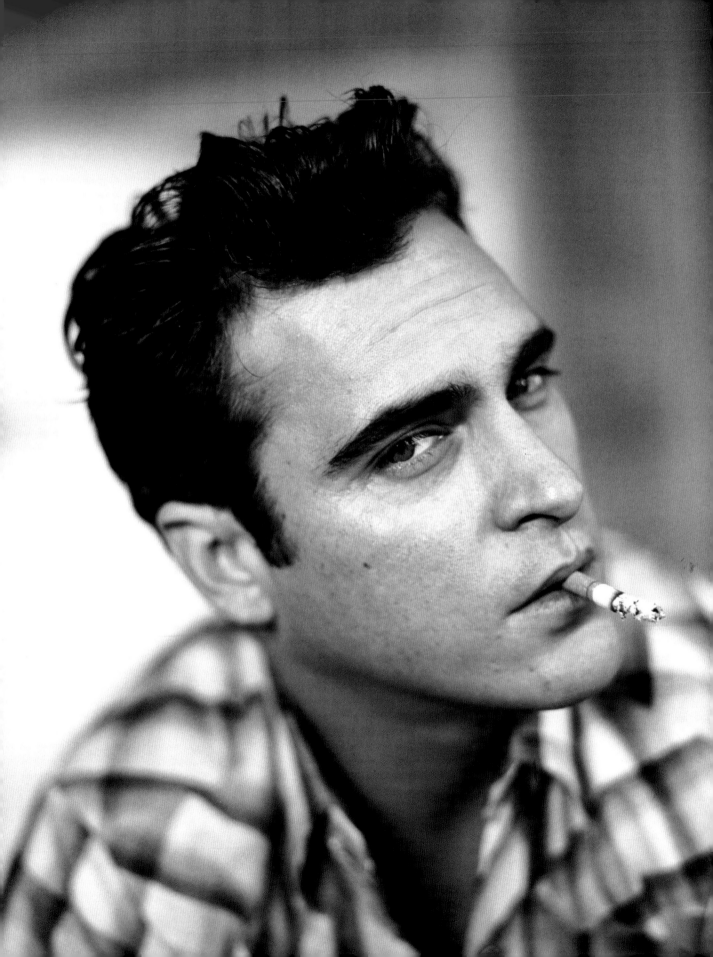

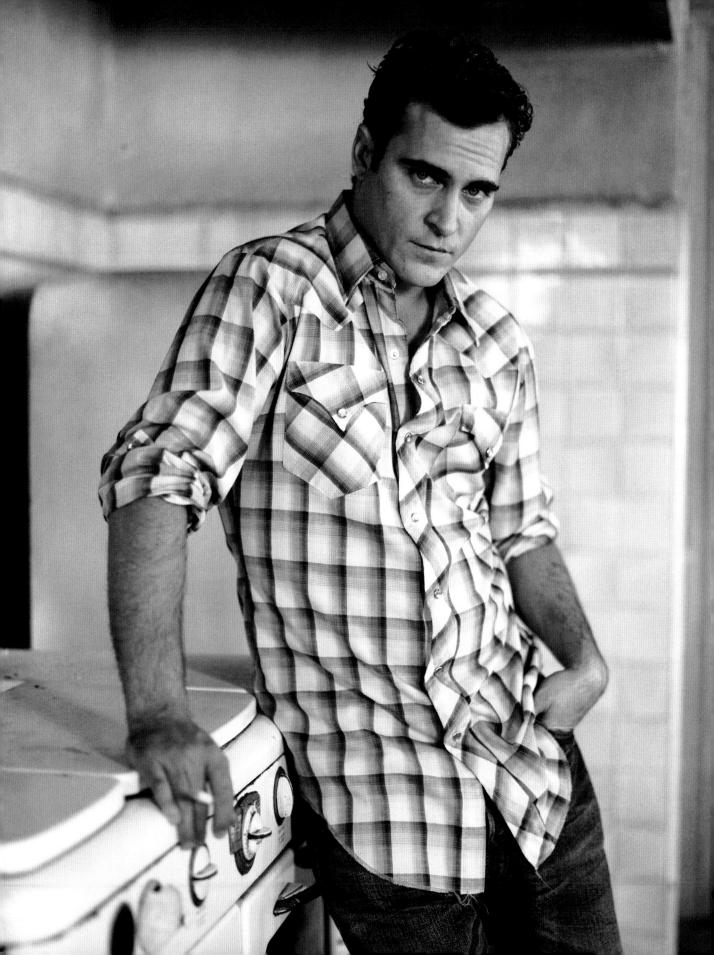

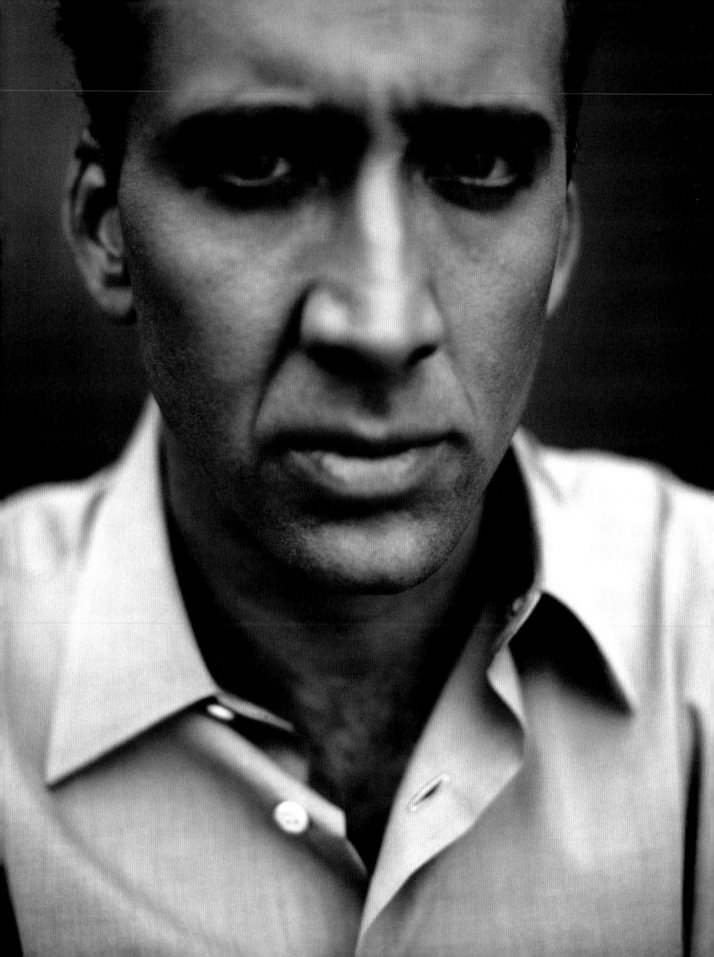

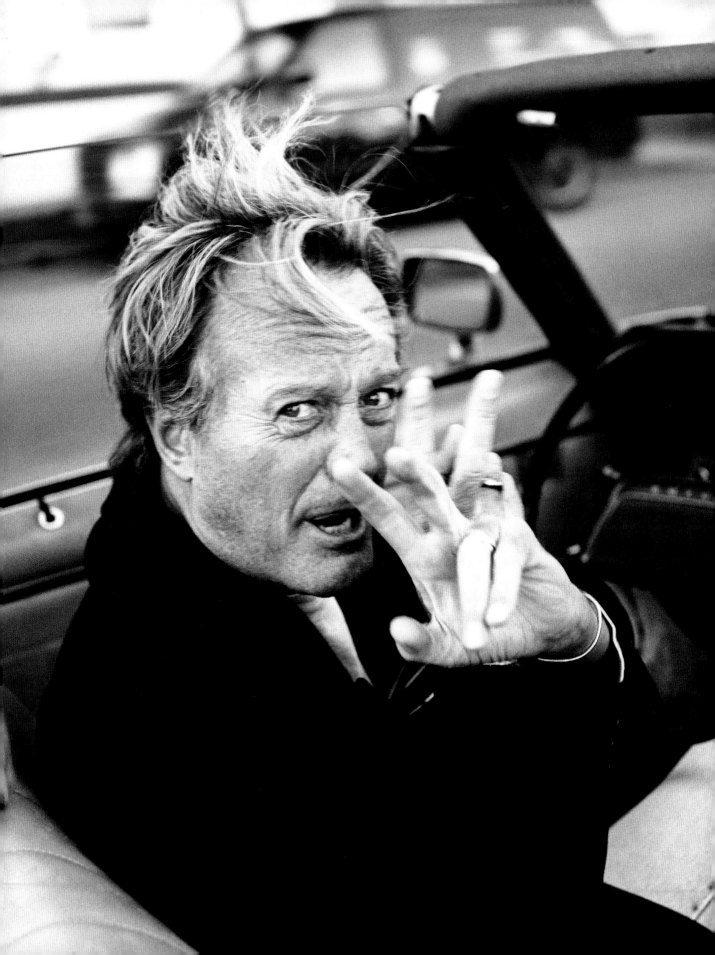

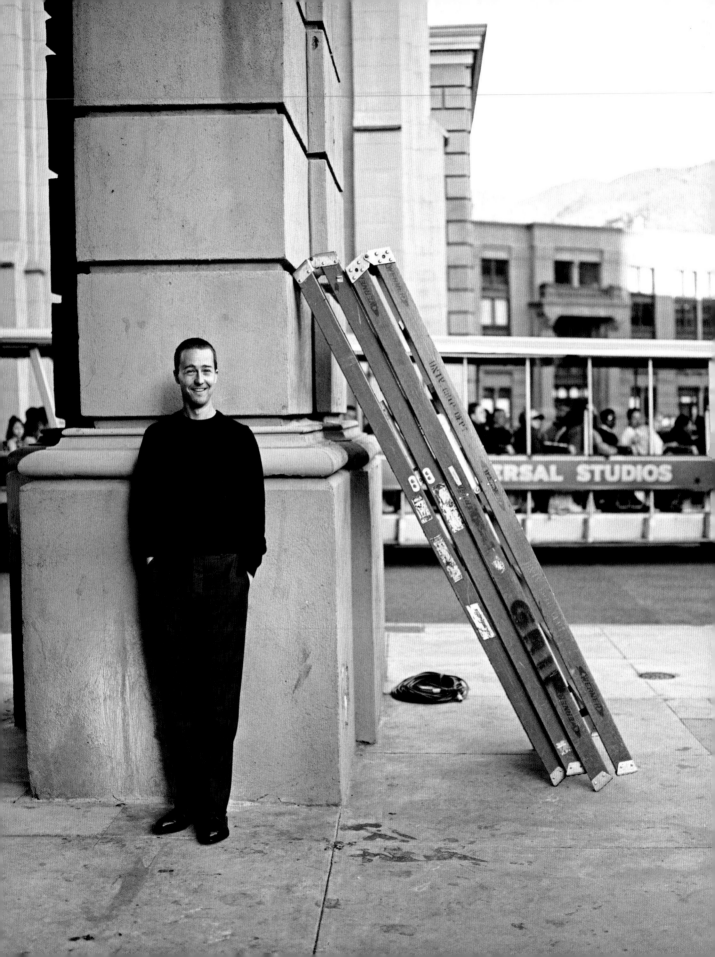

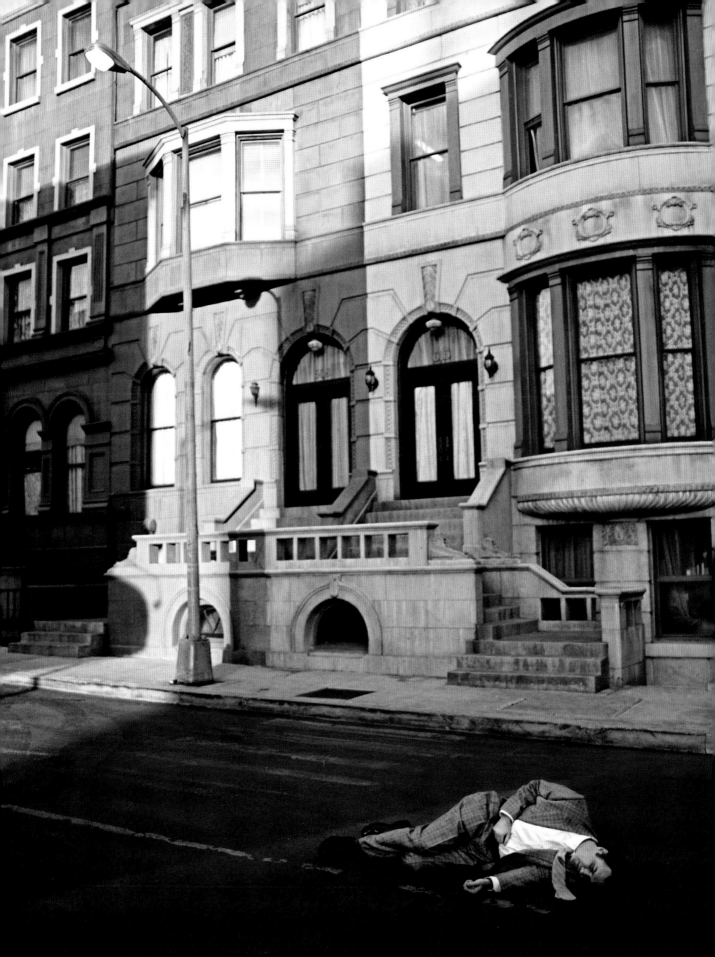

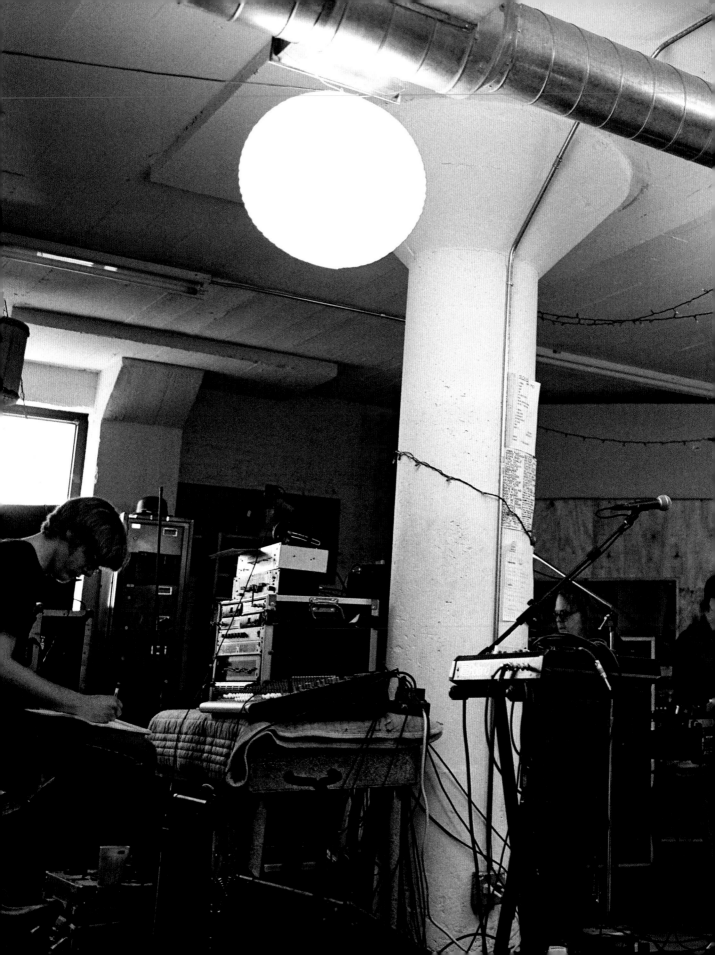

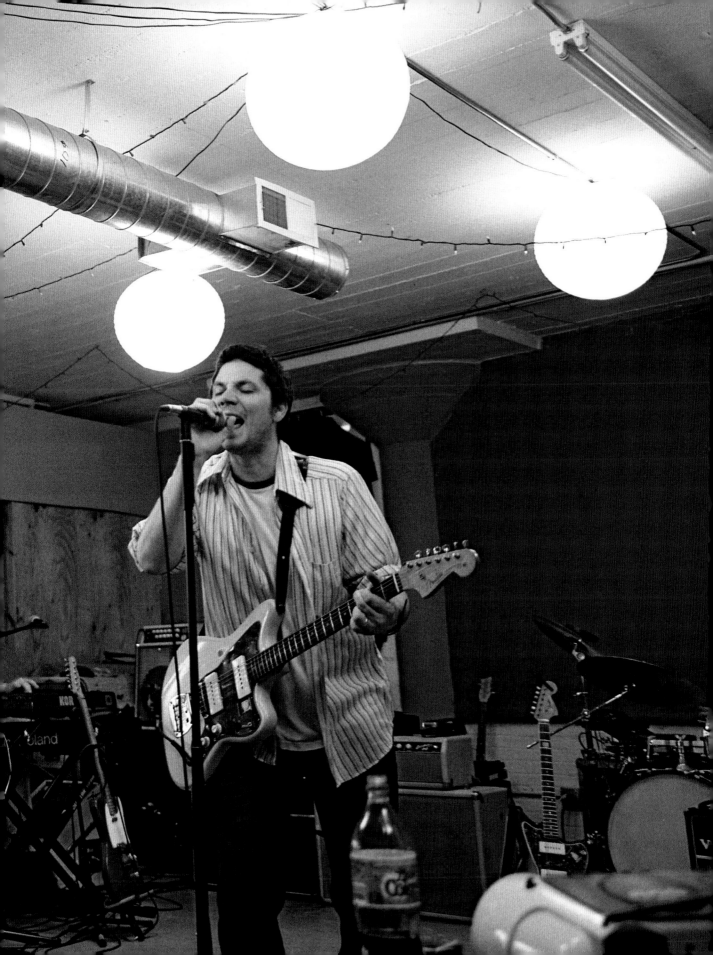

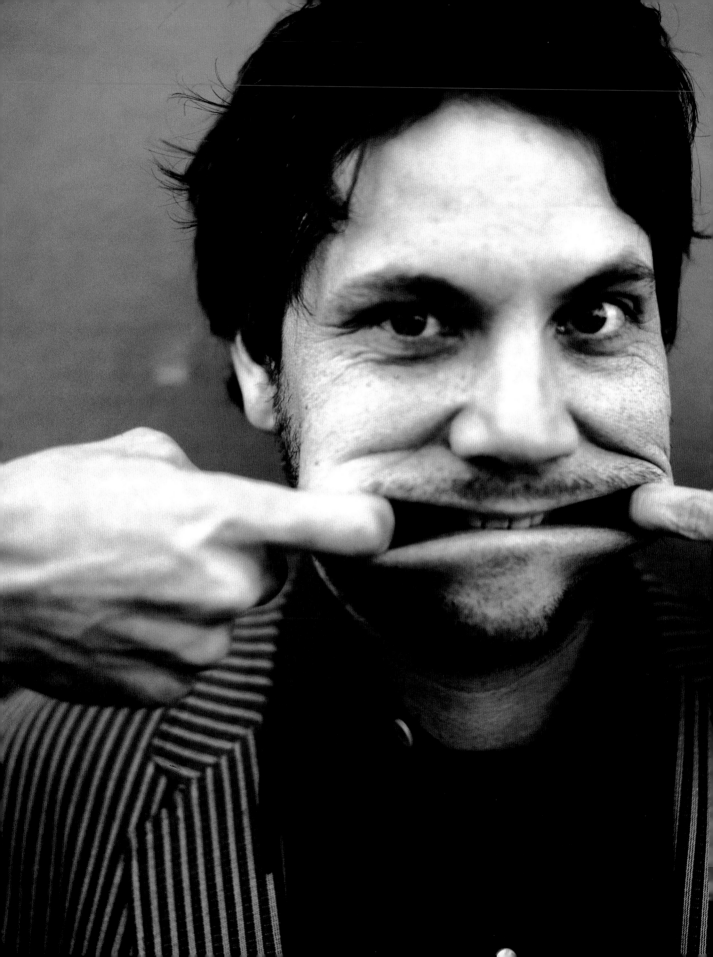

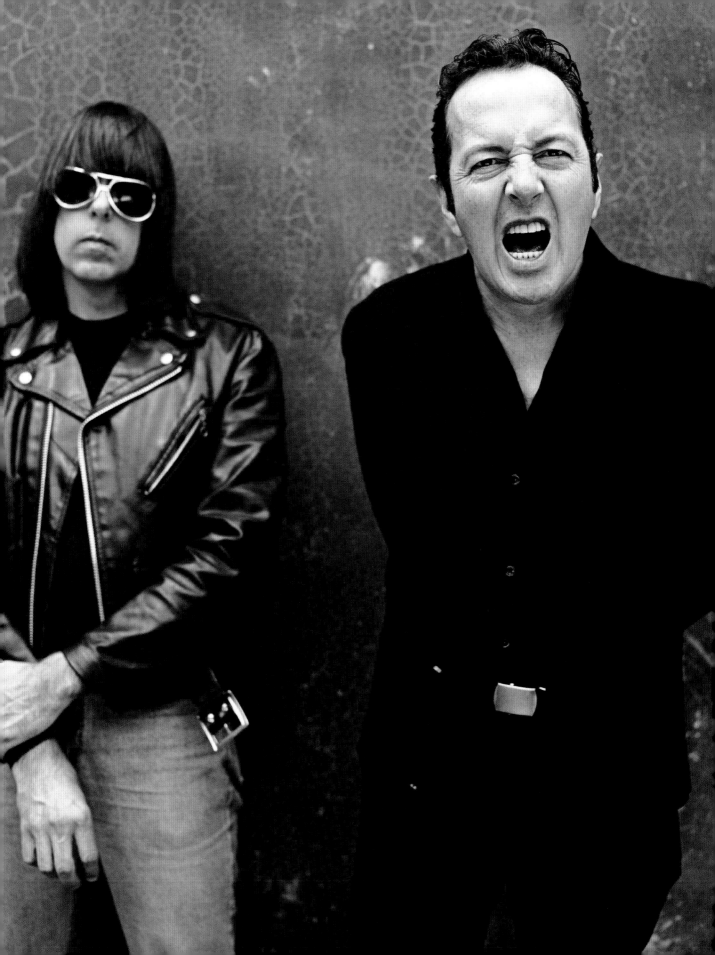

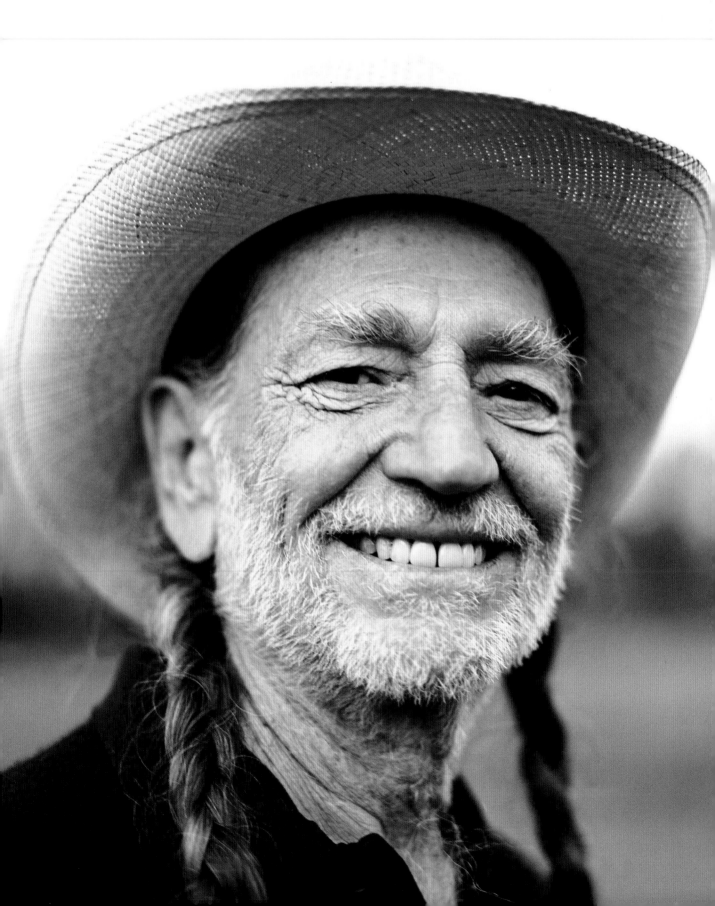

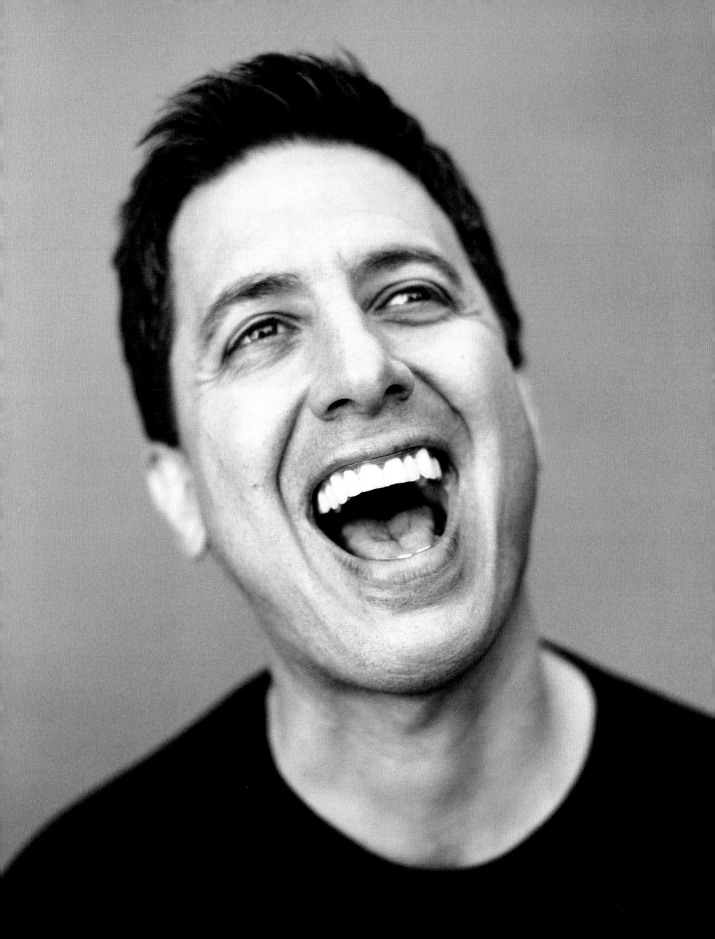

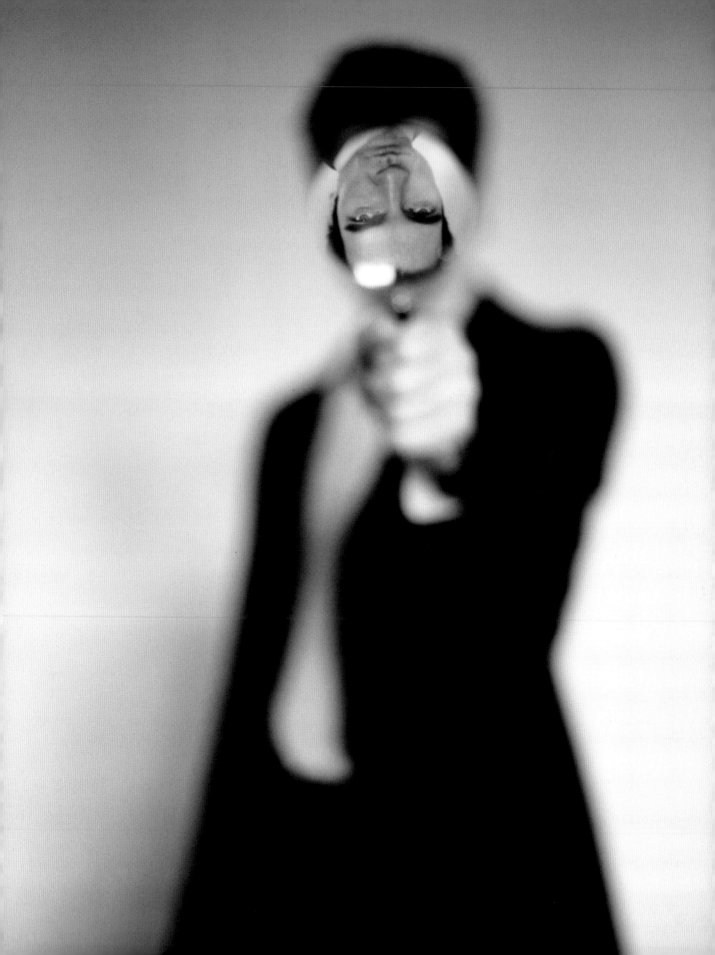

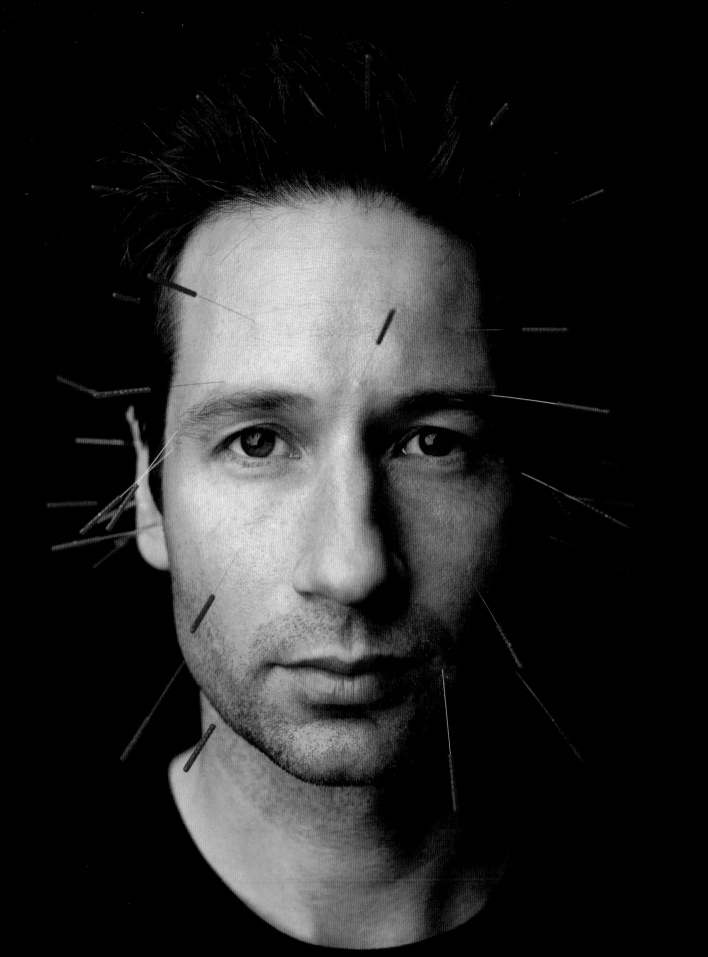

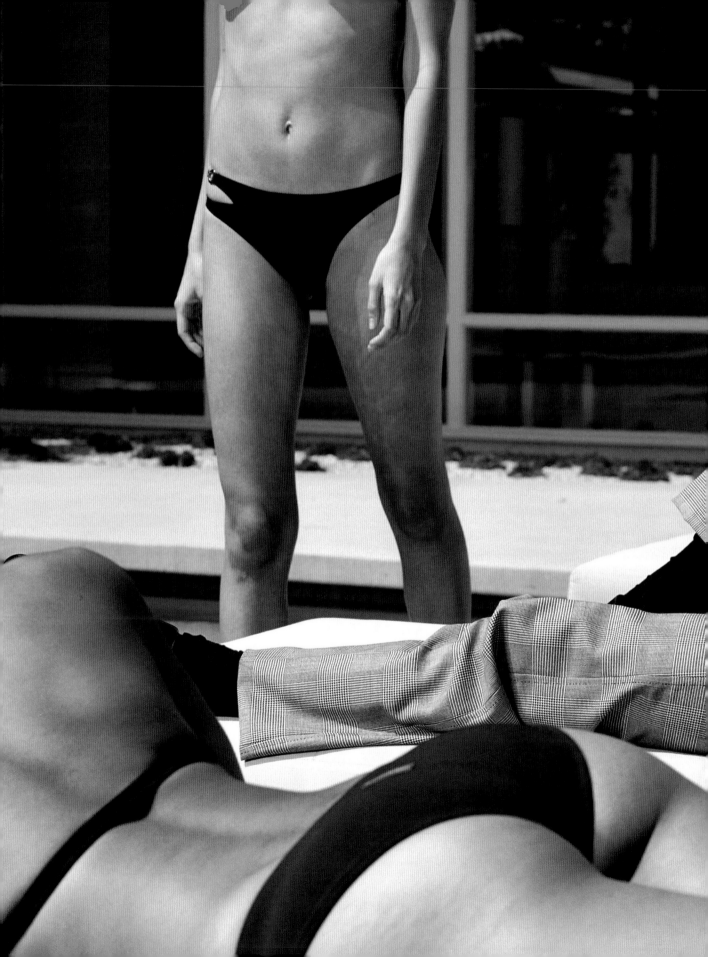

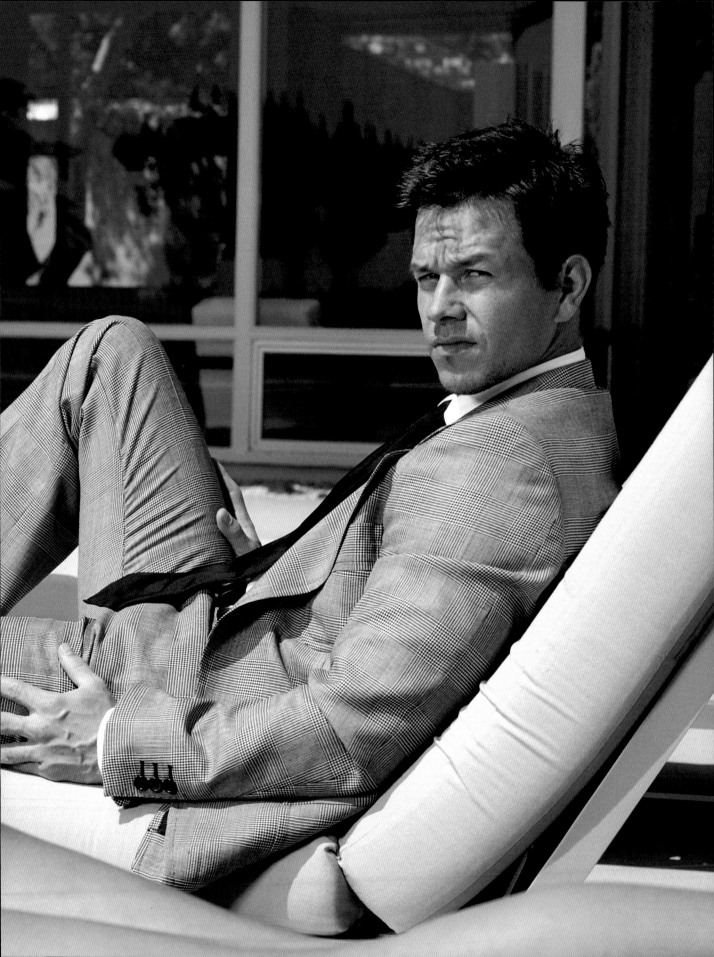

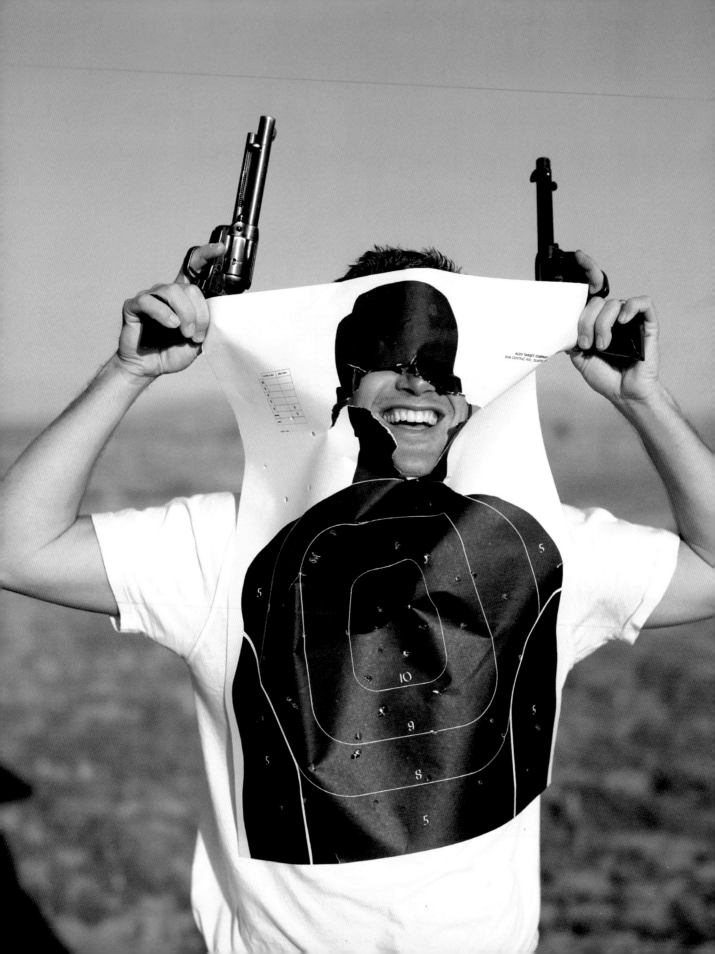

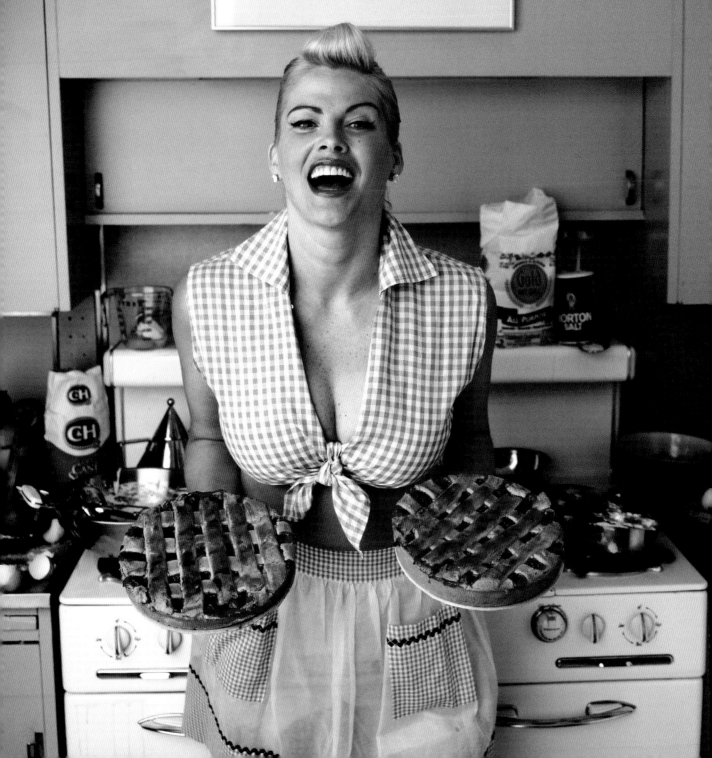

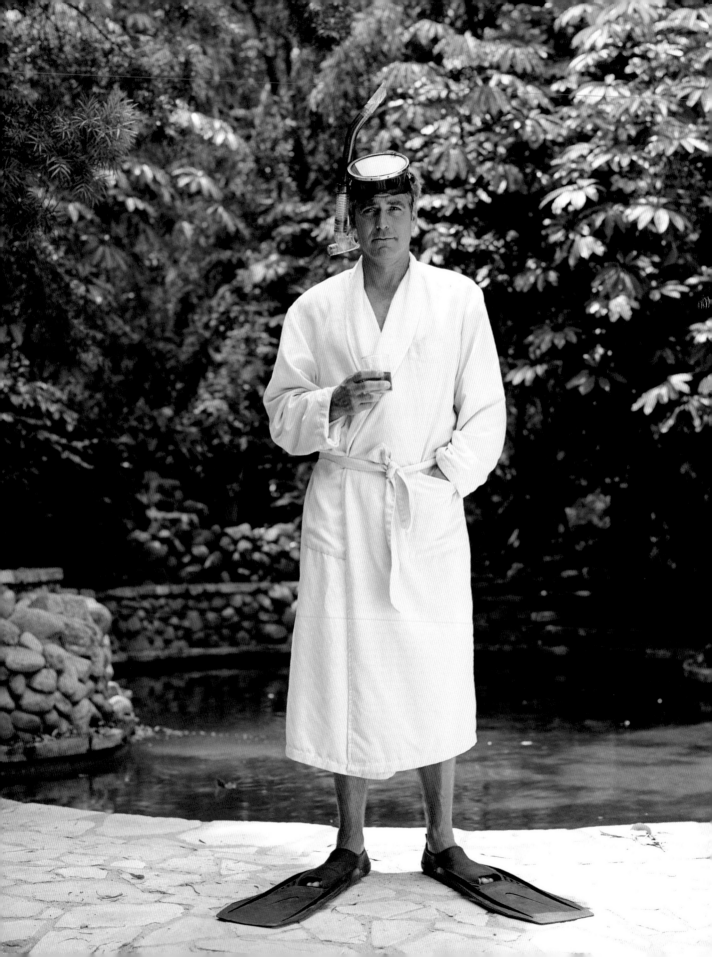

INDEX »

George Clooney on the Universal Studios backlot, Burbank, California

Barenaked Ladies, Big Sky Studios, New York City, New York

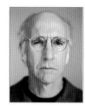
Larry David at a residence in Hollywood, California

George Clooney in his swimming pool, Los Angeles, California

Renée Zellweger at a residence in Alta Dena, California

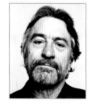
Robert DeNiro, Tribeca neighborhood, New York City, New York

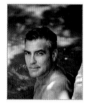
George Clooney in his swimming pool, Los Angeles, California

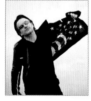
Bono, Smashbox Studios, Culver City, California

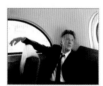
Dustin Hoffman on a bus, Santa Monica, California

George Clooney in his office on the Warner Bros. lot, Burbank, California

Tom Cruise, Smashbox Studios, Culver City, California

Steve Martin on the Universal Studios backlot, Burbank, California

George Clooney in his kitchen, Los Angeles, California

Tom Cruise, Smashbox West, Santa Monica, California

Will Ferrell with soap bubble beard, Universal Studios backlot, Burbank, California

George Clooney in his backyard, Los Angeles, California

Chris O'Donnell leaps a tumbleweed, Lancaster, California

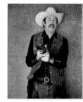
Will Ferrell on the Universal Studios backlot, Burbank, California

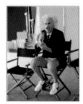

Will Ferrell,
Smashbox West,
Santa Monica,
California

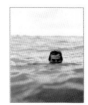

Laird Hamilton,
Hanalei Beach,
Kauai, Hawaii

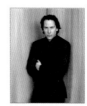

Keanu Reeves
at a residence
in Hollywood,
California

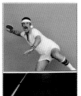

Will Ferrell,
Smashbox West,
Santa Monica,
California

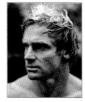

Laird Hamilton,
Hanalei River,
Kauai, Hawaii

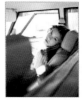

Jessica Biel
in my car,
Beverly Hills,
California

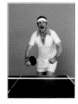

Will Ferrell,
Smashbox West,
Santa Monica,
California

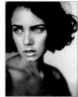

Mia Kirshner,
Santa Monica
Airport,
Santa Monica,
California

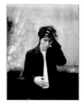

Frances
McDormand,
vacant lot,
Santa Monica,
California

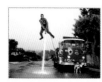

Chris Rock,
Griffith
Park area,
Los Angeles,
California

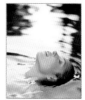

Tamia at a
residence in
Brentwood,
California

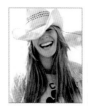

Elle Macpherson,
Trancas Beach,
Malibu, California

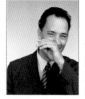

Tom Hanks, L.A.
Lofts Studio,
Los Angeles,
California

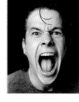

Mark Wahlberg
on the
Paramount
Pictures lot,
Los Angeles,
California

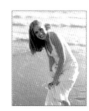

Amy Adams,
Malibu Colony,
Malibu, California

Seth Rogan,
Universal
Studios backlot,
Burbank,
California

Travis Fimmell at
a residence
in Los Angeles,
California

Alicia Silverstone
at a residence in
Los Angeles,
California

Paris Hilton,
Quixote
Studios,
Los Angeles,
California

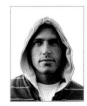
Kelly Slater,
Harry's Beach,
Malibu,
California

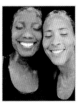
Jenny Johnson
Jordan and
Annett Davis,
Will Rogers
State Beach,
Santa Monica,
California

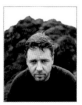
Russell Crowe,
Haggerty's,
Palos Verdes,
California

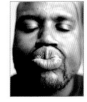
Shaquille
O'Neal at
his home
in Florida

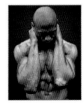
Eddie George
at the Pro Bowl,
Oahu, Hawaii

Ben Affleck,
Smashbox
Studios,
Santa Monica,
California

Shaquille
O'Neal at
his home
in Florida

Lokalani
McMichael,
Smashbox
Studios,
Culver City,
California

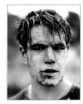
Matt Damon,
Santa Clarita,
California

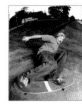
Stacy Peralta,
Mar Vista
Elementary,
Mar Vista,
California

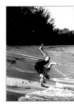
Andy Irons,
North Shore,
Oahu, Hawaii

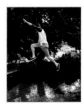
Matt Damon,
Santa Clarita,
California

Stacy Peralta,
Mar Vista
Elementary,
Mar Vista,
California

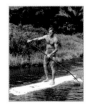
Laird Hamilton
paddling near
his home on the
Hanalei River,
Kauai, Hawaii

Heath Ledger,
Franklin
Canyon,
Beverly Hills,
California

Jenny Johnson
Jordan, Will
Rogers State
Beach, Santa
Monica,
California

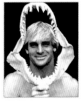
Laird Hamilton
at his home,
Kauai, Hawaii

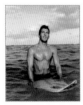

Andy Irons,
North Shore,
Oahu, Hawaii

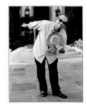

Jack Nicholson
at a residence
in Beverly Hills,
California

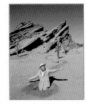

Chuck Jones,
Vasquez Rocks,
Agua Dulce,
California

Emmitt Smith
at the Pro Bowl,
Oahu, Hawaii

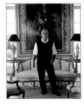

Jack Nicholson
at a residence
in Beverly Hills,
California

David Hyde
Pierce with Duck,
Paramount
Pictures,
Los Angeles,
California

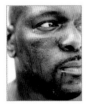

Alex Rodriguez
and a Little
League player,
Miami Beach,
Florida

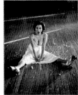

Jennifer Tilly,
Ebell Club,
Los Angeles,
California

Drew Carey,
Fifth and
Sunset Studios,
Los Angeles,
California

Kobe Bryant,
Smashbox
Studios, Culver
City, California

Steve Carell
on the
Universal
Studios lot,
Burbank,
California

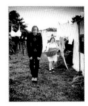

David Spade
in a backyard,
Santa Monica,
California

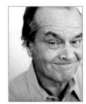

Jack Nicholson
at a residence
in Beverly Hills,
California

Mel Gibson,
Universal
Studios backlot,
Burbank,
California

Owen Wilson
and Wes Anderson
on Gay Street,
New York City,
New York

Jack Nicholson
at a residence
in Beverly Hills,
California

Jamie Foxx
as Ray Charles
at Ray Charles's
Studio in
Los Angeles,
California

Michael Penn and
Aimee Mann on
the Paramount
Pictures backlot,
Los Angeles,
California

 Greg Kinnear, Arcadia, California

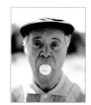 Jack Lemmon, Brookside Golf Course, Pasadena, California

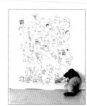 Matt Groening drawing his characters at Smashbox Studios, Culver City, California

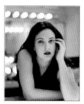 Drew Barrymore at the 92nd Street Y, New York City, New York

 George Clooney, Cabo San Lucas, Mexico

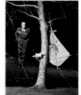 Matthew Perry at Clover Park, Santa Monica, California

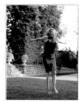 Renée Zellweger at a residence in Alta Dena, California

 Annette Bening at a residence in Pasadena, California

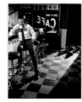 Kiefer Sutherland, Lacey Street Studios, Los Angeles, California

 Renée Zellweger at a residence in Alta Dena, California

 Annette Bening at a residence in Pasadena, California

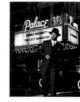 Ice Cube at the Palace Theatre, Los Angeles, California

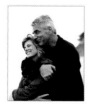 Katharine Ross and Sam Elliot on the beach, Malibu, California

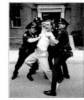 Matthew McConaughey on the Universal Studios backlot, Burbank, California

 Benicio Del Toro in a 1976 Cadillac, Culver City, California

 Richard Gere at a residence in Montauk, New York

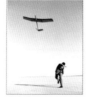 Paul MacCready throwing a glider at El Mirage Dry Lake, El Mirage, California

 Joaquin Phoenix at a residence in Los Angeles, California

Joaquin Phoenix at a residence in Los Angeles, California

Jeff Tweedy with John Stirratt's and Glenn Kotche's fingers in his mouth, Chicago, Illinois

Mark Wahlberg at a residence in Beverly Hills, California

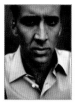
Nicolas Cage, Paramount Studios, Los Angeles, California

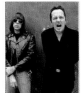
Johnny Ramone and Joe Strummer at the Whiskey, Los Angeles, California

Joan and John Cusack at a residence in Los Angeles, California

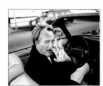
Peter Fonda on Doheny Drive, Beverly Hills, California

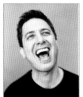
Willie Nelson on his golf course, Pedernales, Texas

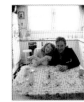
Joan and John Cusack at a residence in Los Angeles, California

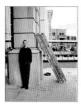
Ed Norton hiding from the tram on the Universal Studios backlot, Burbank, California

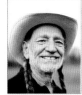
Ray Romano at Rancho Park Golf Course, Los Angeles, California

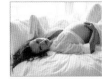
Tori Amos at her home in Florida

Chris O'Donnell in a field in Lancaster, California

Norm MacDonald on the Paramount Pictures backlot, Los Angeles, California

Dylan McDermott at a studio in Atwater Village, California

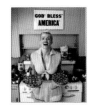
Anna Nicole Smith at a residence in Los Angeles, California

Jeff Tweedy at the Wilco loft, Chicago, Illinois

David Duchovny, Smashbox Studios, California

George Clooney in his backyard, Los Angeles, California

ACKNOWLEDGMENTS

I owe a debt of gratitude to all the people who have agreed to stand in front of my camera over the years and follow my direction. These pictures would not be possible without their cooperation, collaboration, and willingness to experiment. I also am grateful to the magazine editors who gave me so many wonderful opportunities to learn my craft on their dime. And last, thank you to every producer, photo assistant, stylist, hair and makeup artist, prop stylist, set designer, animal wrangler, stunt coordinator, location scout, publicist, and agent who worked their butts off to help make these pictures a reality.

I want to thank my agent, Carol LeFlufy, for her support and effort not only on the book, but on each individual shoot. I couldn't have done it without her. I also want to thank Gabrielle Rivera, Neil Kellerhouse, Don Weinstein, Lawrence Azerrad, and Charles Mohr for their valuable contributions and hard work on this book.

I want to thank Brian Young for finding a home for this book, and Maureen O'Brien and Stephanie Fraser for making this whole project come to fruition.

And thank you, most of all, to my wife, Jenn, for believing in me. I love you.